The Lyrical Constructivist: Don Gummer Sculpture

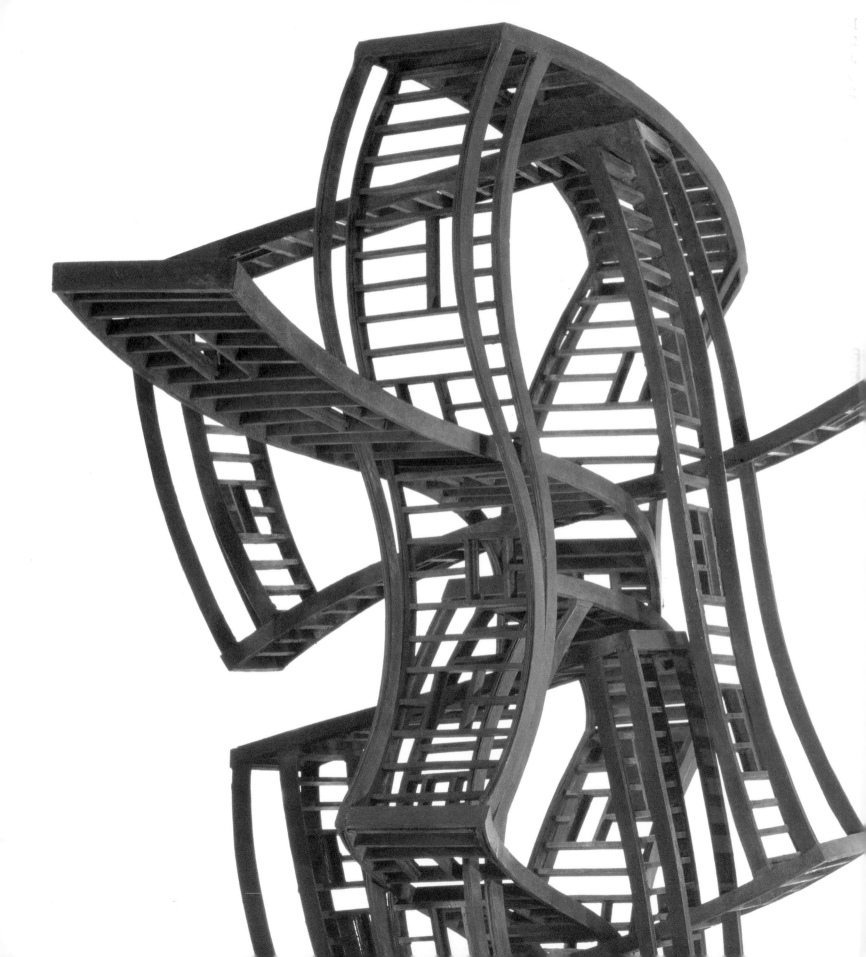

The Lyrical Constructivist: Don Gummer Sculpture

Essay by Peter Plagens

Published by

CHAMELEON BOOKS, INC.
CHESTERFIELD, MASSACHUSETTS

in Association with

EVANSVILLE MUSEUM OF ARTS, HISTORY & SCIENCE
EVANSVILLE, INDIANA

Published by
Chameleon Books, Inc.
31 Smith Road
Chesterfield, MA 01012

Production director/designer: Arnold Skolnick
Editor: Jamie Nan Thaman
Design associate: KC Scott

Printed in China

Published in association with
The Evansville Museum of Arts, History & Science
411 Southeast Riverside Drive
Evansville, IN 47713
www.emuseum.org

Distributed by
The University of Washington Press
P.O. Box 50096
Seattle, Washington, 98145–5096

This book was published in conjunction with the touring exhibition,
The Lyrical Constructivist: Don Gummer Sculpture

DATES OF THE EXHIBITION:

December 2, 2001–February 3, 2002
Evansville Museum of Arts, History & Science, Evansville, Indiana

February 24–April 21, 2002
Butler Institute of American Art, Youngstown, Ohio

September 7–October 27, 2002
Indiana State Museum, Indianapolis, Indiana

ISBN 0-915829-70-3

This book is dedicated with deepest gratitude to the memory of MERRITT and MARTHA DEJONG.

Acknowledgments

As with any project of this substance and scope, a number of individuals played key and valued roles in bringing it to fruition.

First of all, I would like to thank longtime friends Jane and Henry Eckert, of Eckert Fine Art, Naples, Florida, who first introduced me to Don Gummer at an opening of the artist's work in New York City more than fifteen years ago. I must recognize, too, Lawrence Salander and Leigh Morse of the Salander-O'Reilly Galleries in New York City for their caring support and good counsel. Special recognition is due the memory of Margery F. Kahn, a lifelong Museum friend and herself an accomplished abstract sculptor, whose generous Trust made possible the documentary by videographer Matthew Myers and interviewer Trish Myers at IMAGINATION that complements this project. We must recognize, too, Fifth Third Bank for their generous partnership in sponsoring the touring exhibition's inaugural venue in Evansville.

To the Museum's board of trustees and staff—especially James R. Dodd, John Schultz, and Lisa Collins, successive presidents; Mary McNamee Schnepper, curator of collections; Joycelyn Todisco, registrar; Jane Ress Kline, director of development; and Lisa Billingsley, bookkeeper—we offer our thanks for their abiding commitment to this project.

With the completion of our sixth book published in cooperation with Chameleon Books, Inc., we recognize the singular creative gifts of designer Arnold Skolnick and editor Jamie Thaman.

We acknowledge with deepest appreciation the generosity of the project's sponsors at various venues as well as the lenders to the exhibition, who readily shared their resources and their treasures.

Finally, we recognize with gratitude and admiration our friend Don Gummer, whose remarkable vision was the catalyst for these endeavors.

JWS III

Foreword

When we began a search in the mid-1980s for a sculptor with Indiana ties to create a work for the front terrace of our recently renovated Museum, we were referred by friends to Don Gummer, an artist who had grown up in Indianapolis and studied at the Herron School of Art.

As good fortune would have it, he was, within just a few weeks, to be represented in a showing of recent works at Sperone Westwater Gallery in lower Manhattan. The small exhibition turned out to be an interesting mix of vibrantly colored paintings—done while the artist's wife, the actress Meryl Streep, was filming *Out of Africa* on location—and a group of formal, elegantly restrained wooden geometric wall constructions.

The artist would soon visit Evansville and, responding to the row of handsome Victorian and second empire French-style homes facing our building, later create in Indiana limestone, Italian marble, and stainless steel a house-like "architectural homage" suggesting the rooftops, sun-drenched porches, and latticework characterizing an historic neighborhood. This would be Gummer's first museum commission and would also form the basis for a valued professional and personal association that has spanned more than fifteen years.

"I think of myself as a builder," Don Gummer told writer Mary Lynn Kotz for an article in the April 1999 issue of *Sculpture* magazine. Although in the years following the completion of the Evansville piece, Gummer's work has evolved dramatically in both form and theme, there remains in place a strong architectonic quality about his sculpture sometimes reminiscent of the visionary towers of Fritz Lang's 1927 cinematic *Metropolis*. Consistently present, too, is the uncompromising artistic integrity of one who seeks to create only the very best.

With the publication of this book, it is a privilege, indeed, to encourage a broadened awareness of a dynamic and highly original contemporary American sculptor who continues to search, to build, and to dream.

John W. Streetman III
Director
Evansville Museum of Arts, History & Science
Summer 2001

Artist's Statement

The fundamental basis of my sculpture must rest on solid ground, in real life. Gravity, space and time are the three elements that exclusively fill natural reality. I want my work to embrace reality; therefore it must be physically based on these three elements.

The aim of my work is to identify and display creative life through an intuitive manipulation of structure (gravity), shape (space), and movement (time). I begin with the assumption that I can make a sculpture that isolates the moment when natural reality and human emotion unite to form spiritual recognition. The art is in guiding the process from its hopeful beginning to physical completion without compromising the sculpture's true nature.

Don Gummer
July, 2001

THE LYRICAL CONSTRUCTIVIST: DON GUMMER'S SCULPTURE

DON GUMMER could easily have gone either way. Sometime in the 1970s—let's say around the time he made *Ionic Loggia* in December 1977—the young New York sculptor (by way of Kentucky, Indiana, Boston, and New Haven) was teetering on a kind of stylistic razor's edge, between good old-fashioned *sculpture* sculpture and the tempting next big thing of installation art. Let's say between David Smith and Bruce Nauman (with whom, by the way, Gummer was pretty contemporary in terms of pioneering exploration of corridors-as-sculpture). But Gummer's inherently inward-looking sensibility—some might call it a fairly conservative one—led him back to dealing with the coherent sculptural object itself, instead of taking fliers on outright architecture or landscape manipulation. The basic elements of Gummer's sculpture have remained steadfast for twenty years: drawing (with a metaphoric relation to the human figure), the modernist tradition of Constructivism, and a respect for the grace and integrity of particular materials.

He starts by drawing—getting down a basic idea of a piece's configuration and what he wants it to say and do in formalist terms—then extends the idea into a full-size sculpture, using such flammable materials as cardboard, wood, or foamcore. The sculpture is then taken to a foundry and cast in bronze or stainless steel. "Sometimes I feel like a dressmaker," Gummer says. "I go from drawing lines and shapes, to making patterns, then laminating and manipulating them into objects for three-dimensional space."[1] Feeling like a structural engineer would seem more like it. His father was an air-traffic controller, and even as a boy, Gummer had a mechanical bent, making endless model airplanes and boats. Those beginnings most likely laid the foundation for his constructivist (with a small *c* this time) methods.

Another influencing force would be the sculptor George Rickey's book—a favorite of many serious sculptors—on both Constructivism (as in the work of such early twentieth-century artists as Vladimir Tatlin, Naum Gabo and Antoine Pevsner) and constructivism (the general practice of an artist being matter-of-fact in making the work of art).[2] It made Gummer conclude, regarding sculpture, "There's too much hidden in things with covered volume. I like to see every corner, how and why everything was done. You can deconstruct my work and see that it has its own internal logic." As a result, Gummer's art is an art of getting the interior workings of a piece of sculpture *right*, of making

sure the horizontals are aesthetically secure before going vertical, of getting the straight lines to jibe poetically before adding curves to the mix. As he puts it, "Before I can go on to the next phase or the next level, I have to understand the one before it."

Don Gummer was born in Louisville, Kentucky, on December 12, 1946, and moved with his parents to Indianapolis in 1953. His impulse to draw came from his father, who liked to try his hand at linear realism. His father was good, says Gummer, "very precise. But he could only do side views, so they were flat, and stuck to the page." The son one-upped the old man by starting to render objects—he liked to draw boats, airplanes, and horses especially—in three-quarter view. Don was the best artist not only in the house he shared with five brothers but in school, where he was chosen to complete those classic commissions perennially awarded to the most talented kid in the class: decorations for the Christmas dance, sets for the school play, etc. At the time, such assignments were right in line with what the young Gummer thought would lead toward the apex of any career as an artist: working for Walt Disney.

However, Gummer's real—albeit latent—idea of art when he was a kid ran a little deeper, into wondering whether artists weren't merely talented-in-the-hand concocters of facile pretty pictures but mysteriously anointed people. "When I got on the school bus in the morning," he remembers, "I looked at people's hands, trying to figure out whether they were artists." Then, at fifteen, Gummer met two men who rented a house out on Highway 40 in Bridgeport, Indiana, and made a living creating (actually, more like manufacturing) paintings and selling them to both locals and tourists. Gummer says, "One guy drank about forty cups of coffee a day, and was always wired. His paintings looked like David Salle's, only without the irony. The other guy was lumbering. He painted like Neil Welliver; he could start in one corner and go right to the end: finished." The Salle-esque fellow asked Gummer if, for pay, he'd draw about twenty canvases that would later be painted by the man. The job was tolerable, even enlightening and pleasurable, until the New Orleans commission. The same painter asked Gummer to draw some scenes of the Crescent City that would be painted for decorations for a restaurant. Then he asked Gummer to paint the pictures, too. Gummer ended up feeling so angry about having someone sign, under false pretenses, something he'd fashioned entirely by himself that he quit. (And quitting that job was but one example of a stubborn streak in Gummer that emerged again later, in art school, and still undergirds his enterprise as an artist—making, in an age of the almost hysterically unreal, real sculpture.)

Gummer admits that in high school (the five-thousand student Ben Davis High School in Indianapolis), he first took an art class because another, less talented, student told him he'd easily gotten an A in it. At some point he ran into an art teacher who'd been a friend of Glenn Henshaw, an early twentieth-century Baltimore impressionist. She took Gummer to her home and opened a trunk, from which she withdrew some pastels by Glen Cooper Henshaw and spread them out on the floor. "They opened up a whole new world," says Gummer, which was for him the simple revelation that there

were people who tried to express their inner emotions and thoughts, who attempted to make a living by painting exactly what they wanted to paint and then selling their pictures through art galleries. "Senior year," he recalls, "I did nothing but art all day. I knew I was going to go to art school. There was no alternative, no question that I'd do anything else."

He went to the Herron School of Art right there in Indianapolis, still thinking that he'd be an illustrator. But things began to change. Gummer met students from exotic, faraway places such as New York City; listened to Bob Dylan; and started looking at artists like Mark Rothko. He also did some janitoring in the school at night, and he and a fellow student-janitor would do some serious critiquing of work other students had left around. Perhaps because of the after-hours analyses, Gummer started to take his own work more seriously. In fact, when he completed a figurative cast for a classroom assignment, he was so pleased with it he took it home—in violation of the rules about removing student work. He also "borrowed" an instructional cast used in drawing classes. When a faculty member came looking for the casts and found the contraband in Gummer's apartment, Gummer was suspended for two weeks.

That stubborn streak kicked in again, and Gummer systematically made the rounds of his professors, retrieving his work. With it, he was accepted at the School of the Museum of Fine Arts in Boston in 1966. Still an aspiring painter-illustrator, Gummer was hired, on the basis of a portfolio of realist work, as a part-time staff artist for a local television station in Dorchester. "I'd get on the subway every day after school, and go out there," Gummer says. "They'd be doing Bozo the Clown in one studio, and I'd be doing illustrations for 'The Movie of the Week' in another."

The TV money was good (relative to a bohemian student's typical earned income), but Gummer was nevertheless dissatisfied on another front. He'd already put in two years in painting at Herron, but the Museum School had him slotted as a second-year student. He complained to Jan Cox, a Boston abstract expressionist on the faculty. Cox told him to switch to printmaking. Gummer did. But after some campus political agitation (of which he was a part) made it possible for students to choose a concentration from a wide selection of electives, Gummer switched again, this time to sculpture. He did well enough there to be selected for the fifth-year program and a fellowship. With the fellowship, Gummer went off to hitchhike through Europe.

Because of the war in Vietnam and his feelings toward it, he thought he might stay away indefinitely. He traveled in North Africa and entertained a romantic notion of "going all the way down the Nile," but he began to miss making art. At first, he thought he might be able to just go someplace else—say, Mexico—and make art, pure and simple. Gummer even had a little Volkswagen 1600 station wagon outfitted for the long drive, and was about to depart. "I was sitting in the car in Cambridge, all ready to go," he says. "Then I thought about grad school at Yale, which was known as the best place. I called them and was told I'd missed the application by a day. So I got some slides together, drove down to New Haven, said that I was sorry I was late, but I'd still like to apply."

At Yale (where his classmates included sculptors Judy Pfaff and Haim Steinbach, and painters Joe Santore and James Biederman), Gummer studied mainly with David von Schlegell, the renowned author of large and elegant stainless-steel sculpture. (An aside: von Schlegell tends to get short shrift,

art historically, when his work is compared to both less "pretty" sculpture from such predecessors as David Smith and the post-minimalism of younger radicals like Richard Serra. He's due for a revision upward.) There were critiques by Serra and Robert Morris, as well as one of the West Coast artist Llyn Foulkes's pop-surreal "rock" paintings Gummer had spied on a visit to the Rose Art Museum at Brandeis University. Along with every other ambitious young artist in the country, Gummer read *Artforum* magazine; like a few of them, he also tried to plow through some of the heavier primary source material for successful '60s artists, such as Merleau-Ponty's *The Phenomenology of Perception*.[3] "I didn't read all of it," he says. "I would fall asleep. But I *thought* one should read it. I stopped reading it, and similar material, after realizing that I was starting merely to illustrate their philosophical concepts."

The upshot of all those influences—some salutary, some not—was that Gummer started to make some earthwork-ish, Robert Smithsonesque "non-site"-like pieces that he assumed conformed to the avant-garde ideas (yes: that's a contradiction, but a common one) then in circulation 70 miles to the south, in the edgier New York galleries. He liked the idea, for instance, of "sculpture as the recontextualization of natural phenomena, of unaltered things brought into aesthetic balance by simple choosing and placing." Gummer would take a cardboard template for the size of rocks he wanted, find what he was looking for on long walks, and then make sculptures with them. For *Separation* (1970), he found a stone that reminded him of Brancusi's *Fish* (1922) and cut it in half. The stone, in its original whole shape, was suspended in a split configuration by guylines above a rectangular patch of grass.

These efforts took place at the end of the reign of straight minimalism (which an art-world wag

SEPARATION
1970, STONE, WIRE, STAINLESS STEEL,
GRASS, AND CEMENT
17.5 X 48 X 36 INCHES
COLLECTION OF THE ARTIST

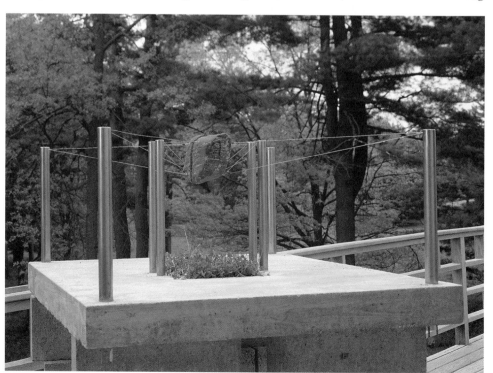

once called "the last of the court styles" of modern art), when art objects—however attenuated, however abstract—were once again being taken to "mean" something. There is no denying that the tension inherent in rocks suspended over oil, grass, or openings in a platform is at least a little more than formalist. Could it actually be sexual? "I think most good work reflects in some way the most intense issues an artist's dealing with at the time," Gummer says, and then adds with that telling, faint smile of his, "At the time, sex was definitely an intense issue." But, as art can be, the work is also about deeper, broader, more profound kinds of tension—different from, but not unconnected to, the sexual: about, in Gummer's words, "feeling tied down, feeling the struggles ahead, secrets coming out, and something beneath the surface just beginning to appear." Those pieces expanded and morphed into the kind of quasi-architectural, almost-installation pieces he came to make—with at least a glance at Robert Irwin's environment-rather-than-object works constructed with tautly stretched "walls" of white nylon scrim—in the mid-1970s. It was from that point that he would find his way back to sculpture.

Of course, the post-Yale Don Gummer (M.F.A., 1973) came down to New York to make his way as an artist. He tried to make a living in construction, but the energy crisis had hit and there weren't many jobs around. He caught a break in knowing a guy who knew a guy who was a representative of Aristotle Onassis. The Greek billionaire (even then) was, through Tishman Construction, building the Olympic Tower on the midtown Manhattan corner of Fifth Avenue and Fifty-first Street. Gummer presented himself at Tishman headquarters in the famous "666" building on Fifth Avenue. Gummer remembers, "There was a big Léger painting on the wall." Asked exactly what he wanted to do, he told the people in the executive suite that he wanted to be a carpenter on a big (and therefore long-running) skyscraper project. All right, they said; show up tomorrow morning with your tools and you're on. Gummer showed up, but the hostility of the grizzled veterans already on the job was obvious, right down to the macho symbolism they used to alienate him—his hammer was judged too small, and his reeled tape measure was deemed inferior to the hard, folding kind. Many of the project's construction workers were ex-policemen, bereft of their former occupations courtesy of the Knapp Commission, which investigated police corruption in the 1970s. The project was always a little scary for Gummer. "One guy really hated me," he recalls. "Once, when I was sent to get the coffee in the morning, this guy asked me to get him a Budweiser. I mistakenly got him a Miller. He said, 'Do you really expect me to drink this pisswater?' I said that I didn't give a damn. I told the foreman that I'd never get coffee again. And I never wanted to turn my back on that guy when we were at the edge of the building."

Fortune intervened, and Gummer won both a Tiffany grant and a National Endowment for the Arts artist's fellowship around the same time. "I also had money saved up from the job," he says. "For me, it was easy street." The inveterate traveler bought a ticket on the old Pam Am flight #1, which used to take off regularly from JFK airport, continuously circling the world westward.

That sojourn was cut short by a serious motorcycle accident in northern Thailand in 1978. When, after a couple of months of healing, he arrived back in New York, he had to find a way of making art that didn't involve long periods of standing upright unsupported. He found that working at a large table while braced against it solved the problem. On the table, Gummer started to rework what he'd previously had on the floor—architectural tropes, window- and doorlike openings to negative space, and just a hint of the peculiar magic that surrounds structures made for meditation or ritual.

More important, Gummer's going to the wall with his sculpture pretty much emptied it of conscious theory-mongering and replaced it with a desire to be more or less beautiful (i.e., the work was once again about how it *did* look, visually, as opposed to how it *might* be read, linguistically). Consequently, he went against the au courant direction of the '70s, which was away from minimalism (that wag might have better said, "the last court style that cared about how art *looks*"), and hurried back to a more traditionally modernist aesthetics.

The fairly immediate result was several skeletal—and almost lacy in so being—wall sculptures that not only challenged what Gummer would likely consider the vulgar volume of more conventional wall sculpture, which usually consists of some form of relief, but managed to be quite lovely (and at times on the brink of being too much so) in the process. Works such as *Ionic Loggia* managed something else quite extraordinary: they countered sculpture's splintered trajectory back into raw nature (earthworks), concept itself (conceptual art), and the first sinister inklings (in early installation art) of

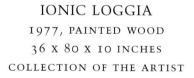

IONIC LOGGIA
1977, PAINTED WOOD
36 X 80 X 10 INCHES
COLLECTION OF THE ARTIST

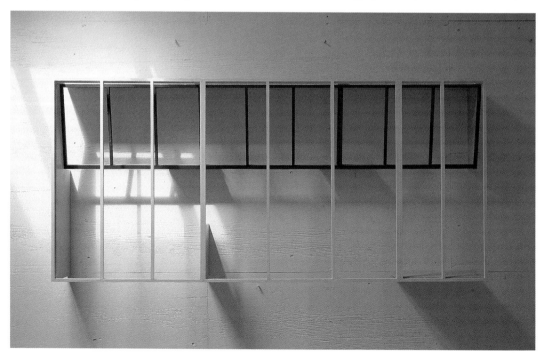

the irony that would eventually swamp the art world and almost completely submerge it by the present day. Gummer took as many risks as his peers who were more outwardly bound sculptors (at least materially); his were just inward: whether to add a diagonal, convert a solid plane to a screen, or work in a curve or two in order to create poetic spatial relationships. Gummer's creative contemporaries were—although he claims no special or particular affinities—less the usual post-minimalist suspects and more the likes of the Russian-Revolutionary painter Kasimir Malevich and the Renaissance architects Bramante, Alberti, and Brunelleschi.

Why didn't Gummer's work—although not exactly unexhibited or unpatronized—have more of the art-world impact that it deserved in the late '70s and early '80s? Part of the reason—probably the greater part—lies in Gummer's simply going against the tide of his time. Not that he thought about it strategically or did it consciously; he was only following his original instincts as an artist. And not that his sculpture was actually conservative in the sense of the word that means, or implies, "hidebound"; it simply opted for a more sharply delineated aesthetic "frame" around a smaller and more intensely occupied artistic territory (i.e., a physically coherent and cohesive art object) than did most of the seriously regarded contemporary sculpture of his time. Another part of the reason is that both Gummer's personality and facets of his life have caused, and still cause, him to be somewhat absent from the in-house-politics circuit of the New York art world. (Being the art critic for a mass-audience general magazine as well as a frequent contributor to one of the more "inside" art publications on the stands, I empathize a bit with Gummer: we both know, both reluctantly and gratefully, the nice, clearer and wider perspective you get when you're not quite all the way "plugged in.")

A former girlfriend of mine had been a dancer in the same dance company at Tufts University in Boston as Harry Streep. Harry asked me if I could do some work on his sister's loft in Manhattan. She was an actress and wanted some soundproofing in the ceiling to baffle the sound of a crying baby upstairs." That's how Gummer met his wife, Meryl. The couple have four children and live a couple of hours outside the city, where he has a studio and sculpture storage. Gummer also has another sculpture studio in Manhattan. An artist having a life like that—filled to the brim with a lot of things, but most prominently among them extremely complicated logistics—can be both a blessing and a disadvantage. One of the disadvantages is having to move and work at art someplace else every once in a while, even if it is temporary. But one of the blessings, coincidentally, is exactly the same thing.

In 1989, Gummer and his family moved temporarily to Los Angeles. He got a studio in Venice, and his sculpture went freestanding again—and vertical. Perhaps it was the lower, flatter architectural landscape of urban southern California exerting an effect on the artist to make something in the studio that would mitigate those qualities, but Gummer has always been very deliberate in adding to his sculpture just one element at a time: cut-throughs, slight tilts, very shallow curves, and deeper curves.

The deeper curves rather naturally—probably inevitably—accelerated into helixes, and another new world opened up for Gummer. As a critic aptly described a 1996 Gummer solo exhibition in New York: "pleasure-seeking rings" versus "sober, straightforward planes."[4]

What Gummer has arrived at in his work of the last few years is, art-historically speaking, a kind of baroque minimalism and, aesthetically speaking, a wonderful spatial fugue on the perennial dualities of sculpture, of whatever century, period, style, or fashion: straight/curved, open/closed, symmetrical/asymmetrical, and, most important, completeness/incompleteness. The last is the most important because it's the quality that draws the viewer into the work again and again, for second, third, fourth, and nth looks. It's the property that allows the revelations of Gummer's Constructivist method—an ever-so-slight intimation of practicality in his forms—to make themselves known. *The Next Phase* (1997), with its real juggling act of a thin center "armature" against a heavy, rectilinear exterior configuration; *Easy Work* (1998), with its delicate balancing almost on pointe; and various interior screens from some of the rhomboid forms could be the best examples, among the works in the exhibition, of Gummer's sculptural profundity.

A big-time art dealer (whom we'll kindly leave nameless) visited Gummer in his studio a while back and said, unembarrassedly, that he found it very "curious" to find an artist still working this way— that is, making integrated sculptural objects in the year two thousand and whatever. At the time (and even more now), a tactical response from the artist might have been to say that the work is deliberately retro, that its digging-in-the-heels in the face of rampant, linguistics-based deconstructionism of most contemporary art is meant to be perceived as an additional "frame" around the sculptural fact.

Not so. That stubborn streak again: "I played baseball back in high school," Gummer says. "I loved baseball. I wanted to be a pro, and I always thought the next guy walking down my street would be a scout. But I didn't like the military aspect of the high school team—a coach yelling at you to do things a certain way." The point? Gummer wasn't making one when he told me the story, but I'll venture one here by connecting it to something else the artist said: "I think that anyone can figure out the gallery game and actually get pretty good at it." (The coach would be, of course, the equivalent of art-world fashion, which, in effect, yells at artists and tells them what kind of art to make.) "That's easy to do," Gummer adds. "Making a resolved piece of sculpture that has a spark of life is hard."

Not only "resolved" sculpture but, in the case of his work, subtly inventive sculpture, deceptively relevant to the current precarious condition of sculpture and, indeed, beautiful. In the end, that's the direction where the sculpture of Don Gummer has really gone.

1. Conversations with the artist, winter/spring 2001.
2. George Rickey, *The Origins and Evolution of Constructivism*, New York: George Braziller, 1967.
3. For those who'd like to sample for themselves: Maurice Merleau-Ponty, *The Phenomenology of Perception*, New York: Routledge, 1962.
4. Lee Siegel, untitled review, *Artnews*, November 1996, p 134.

The Sculpture

All height measurements include the base.
Castings by Argos Foundry Inc., Brewster, New York,
& Fine Arts Foundry, Los Angeles, California

SUMMER SANCTUARY
1982, PAINTED WOOD, 79 X 105 X 17 INCHES
COLLECTION OF THE ARTIST

THREE PENTAGONS
1990, PAINTED WOOD, 93 X 67 X 16 INCHES
COLLECTION OF THE ARTIST

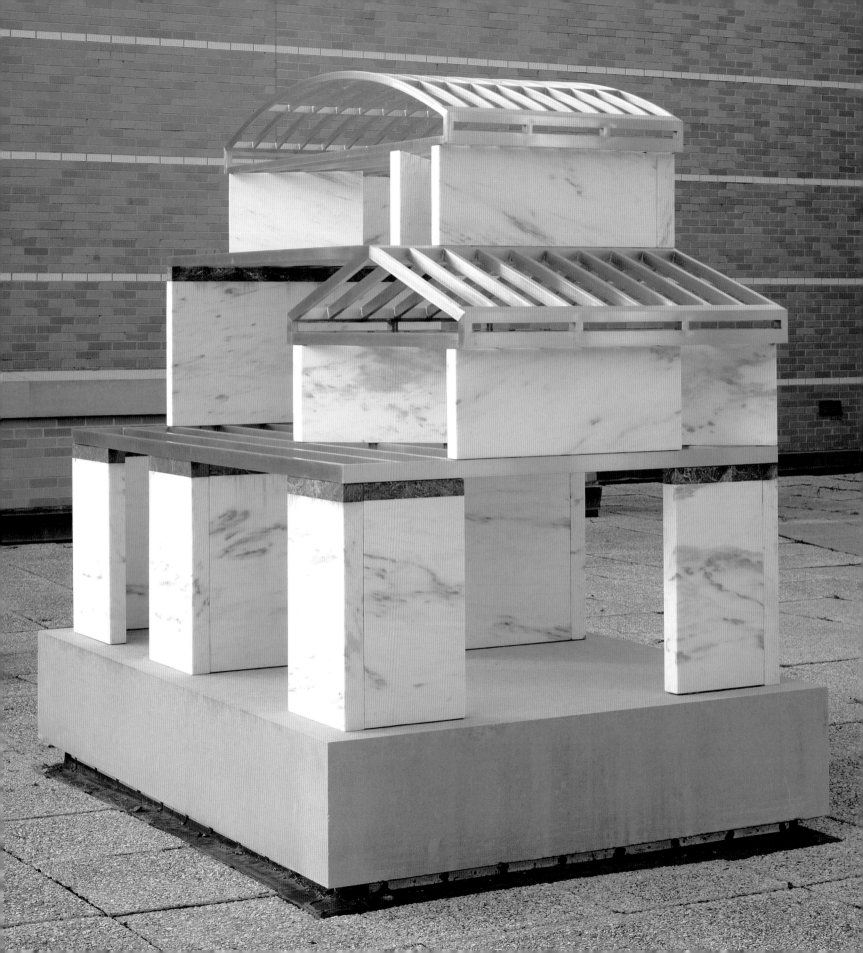

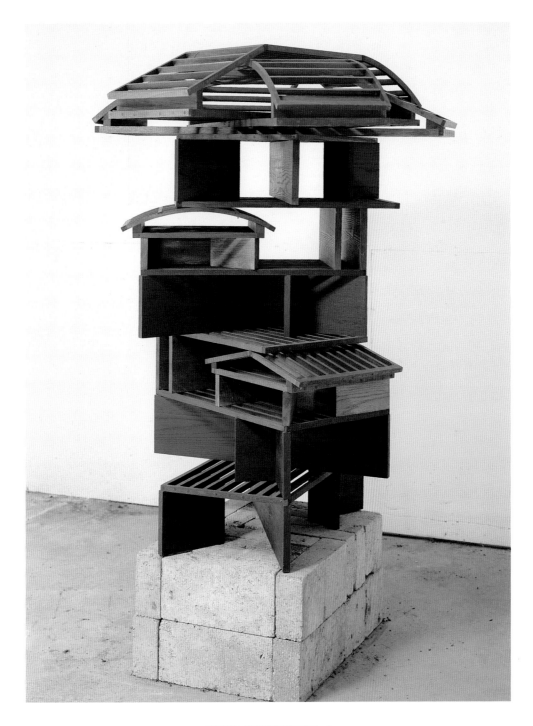

THE OBSERVER 1
1988, STAINED WOOD, 79 X 48 X 48 INCHES
COLLECTION OF THE ARTIST

THE PLANES OF NATURE
1987, STAINLESS STEEL, MARBLE, AND LIMESTONE, 93.5 X 92 X 68 INCHES
PERMANENT INSTALLATION AT THE EVANSVILLE MUSEUM OF ARTS, HISTORY & SCIENCE, EVANSVILLE, INDIANA

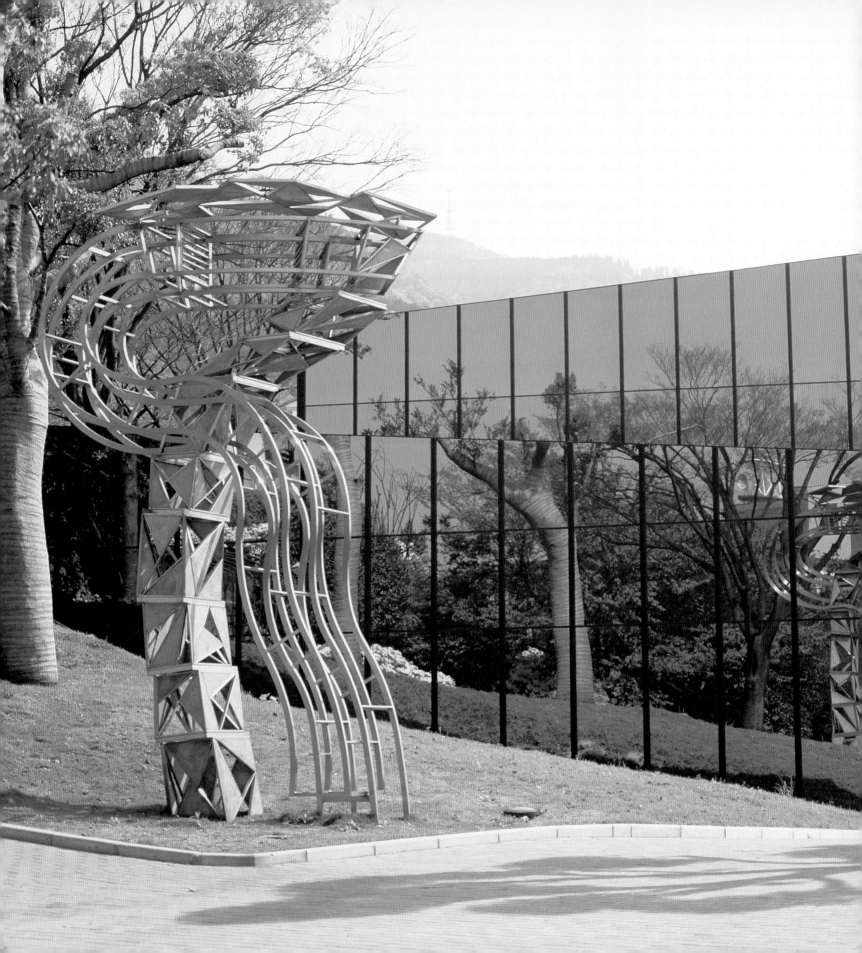

REUNION
1993, CAST BRONZE AND STAINLESS STEEL, 200 X 128 X 36 INCHES
PERMANENT INSTALLATION AT THE KITAKYUSHU INTERNATIONAL CENTER, KITAKYUSHU, JAPAN

REUNION (MODEL BEFORE CASTING)
1992, FOAM CORE AND BALSA WOOD, 100 X 54 X 18 INCHES

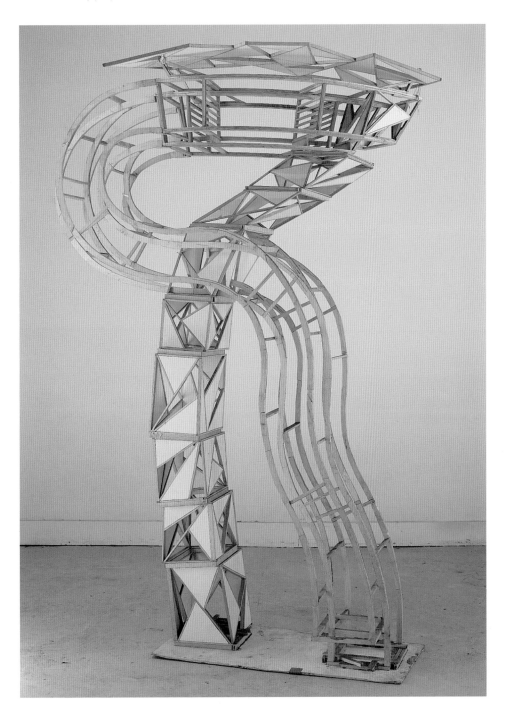

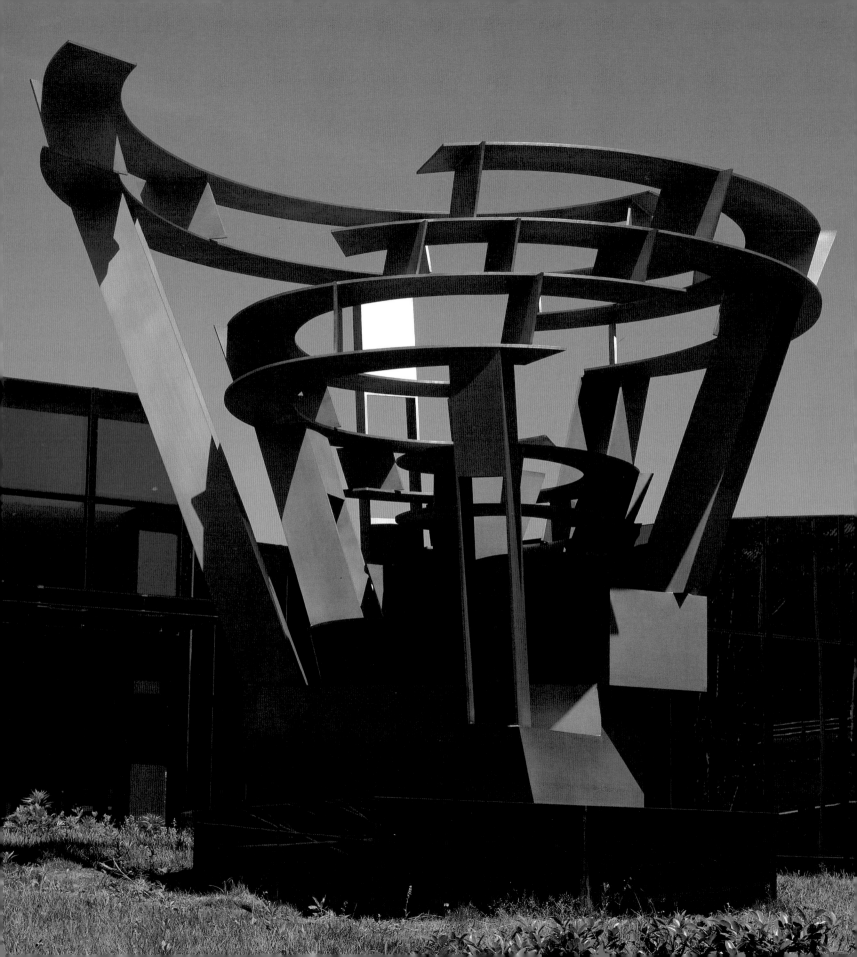

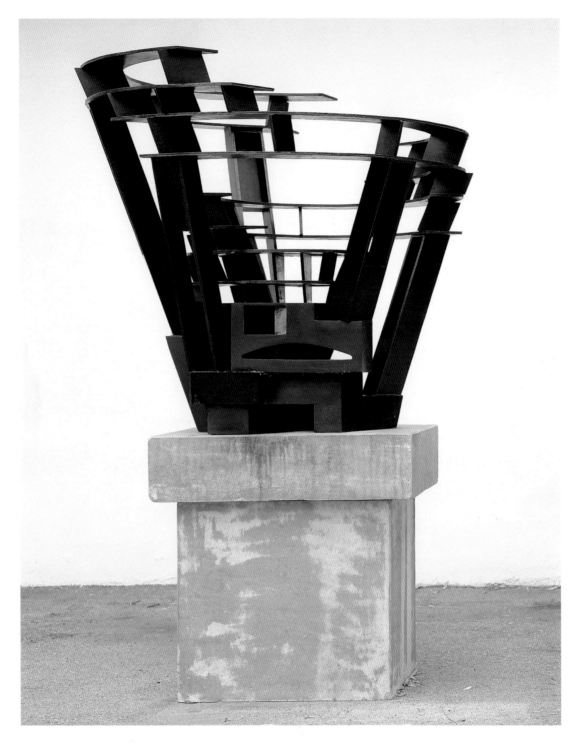

HOUSE OF MUSIC (MODEL)
1993, CAST BRONZE, 80 X 56 X 52 INCHES
COLLECTION OF THE ARTIST

HOUSE OF MUSIC
1993, STAINLESS STEEL, 173 X 168 X 156 INCHES
PERMANENT INSTALLATION AT THE HIBICKI CONCERT HALL, KITAKYUSHU, JAPAN

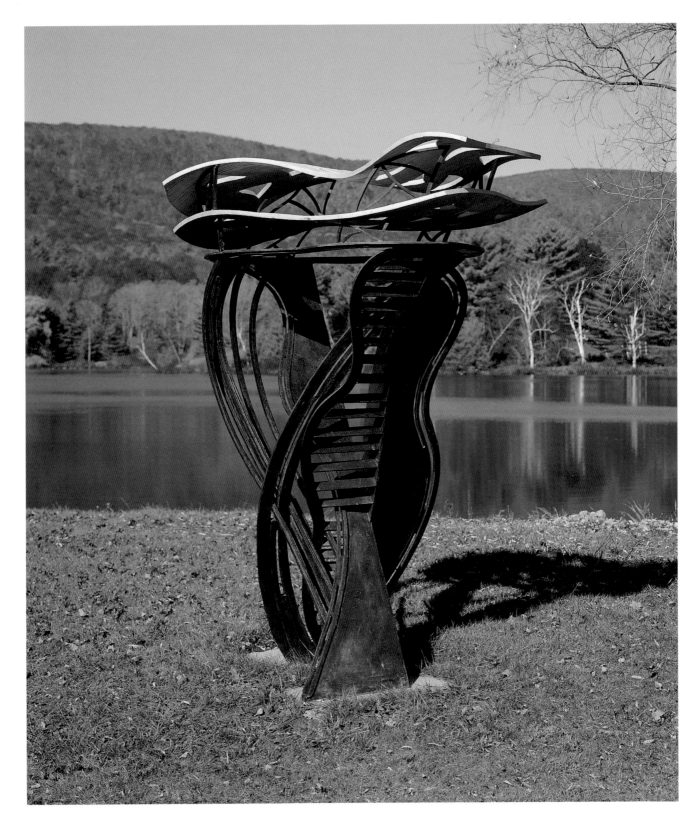

RECLINING WOMAN

1993, CAST BRONZE AND ALUMINUM, 94.5 X 86 X 42 INCHES

COLLECTION OF THE ARTIST

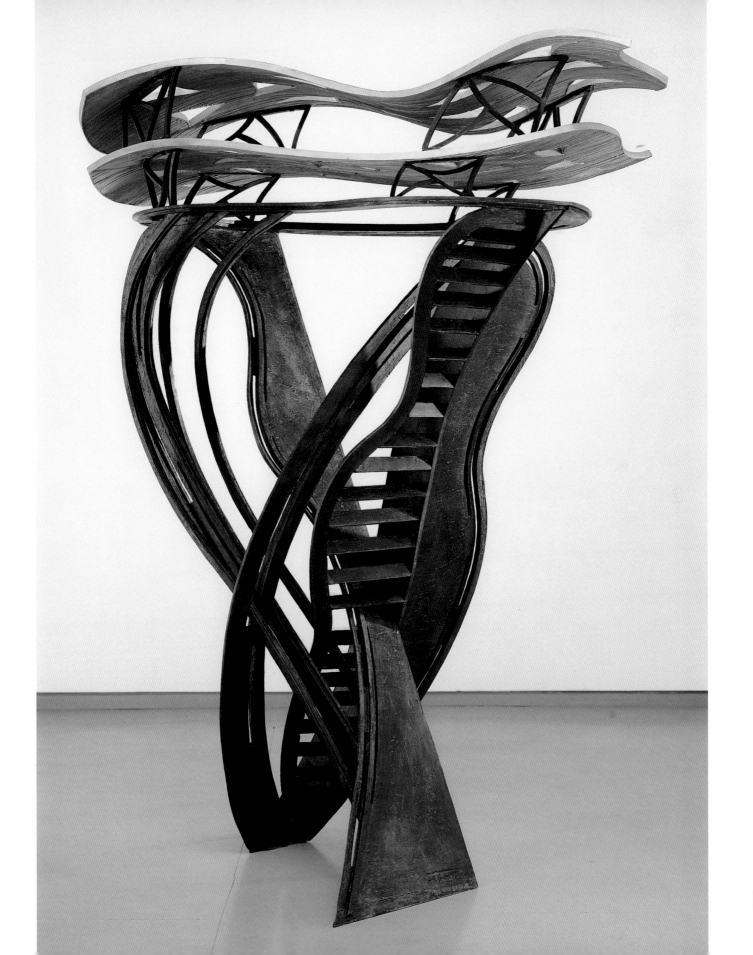

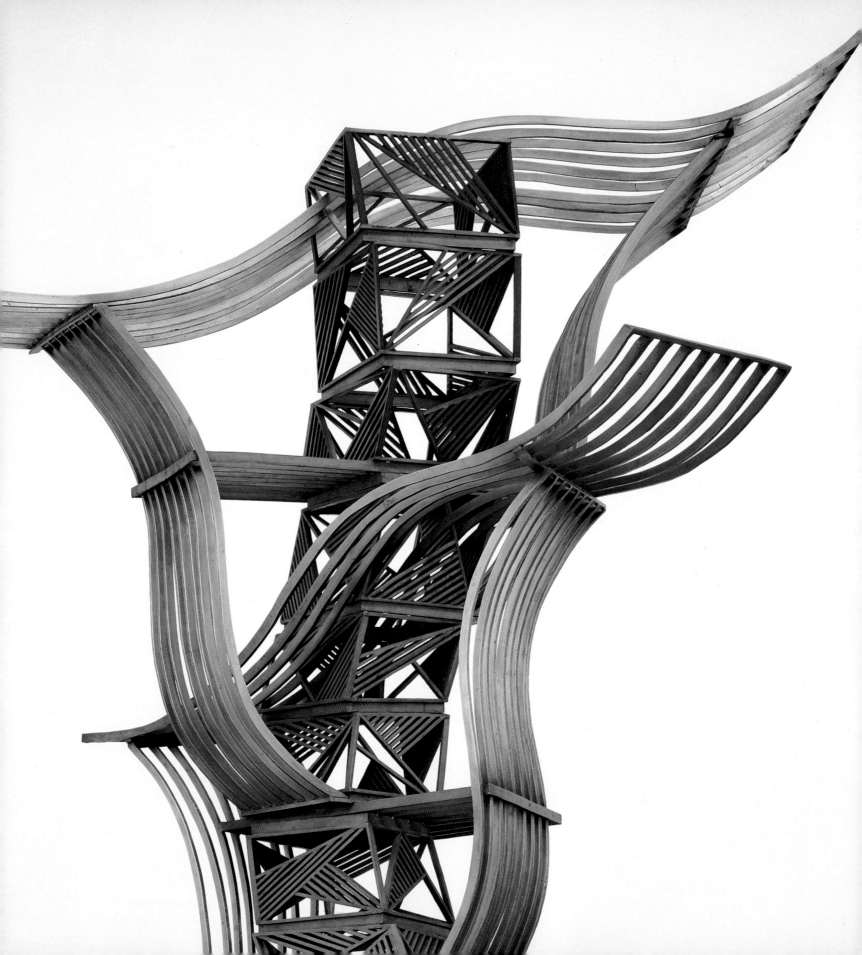

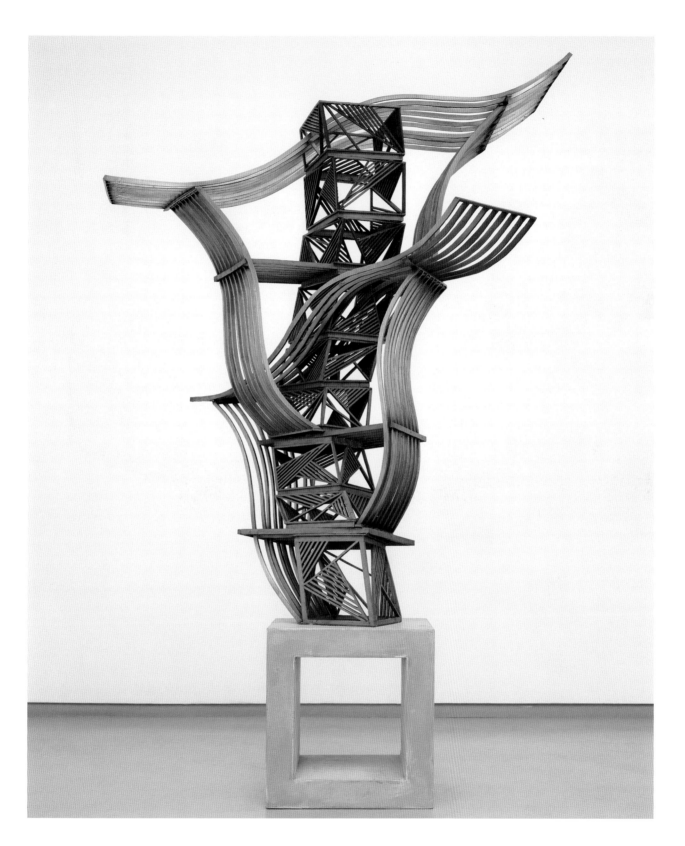

PASSAGE
1993, CAST BRONZE, 106.5 X 66 X 56 INCHES
COLLECTION OF THE ARTIST

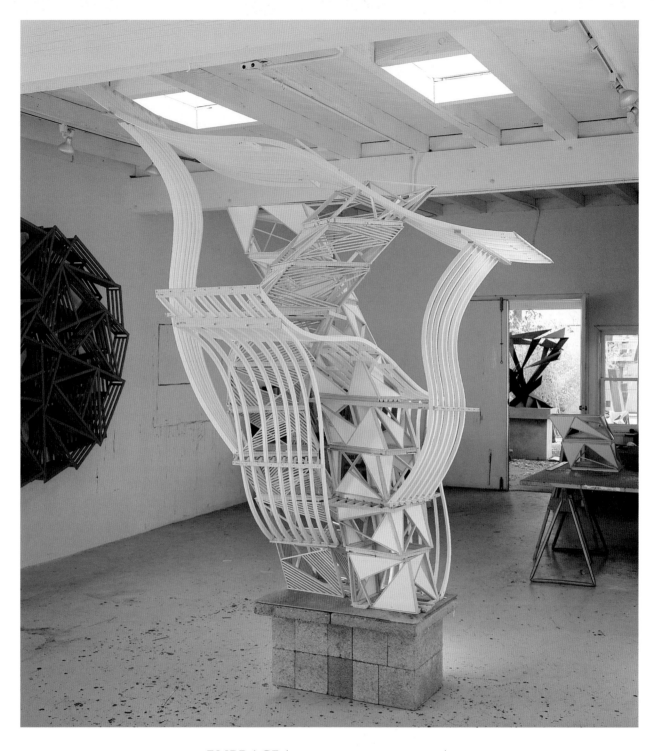

EMBRACE (MODEL BEFORE CASTING)
1994, FOAM CORE AND BALSA WOOD, 102.5 X 96 X 84 INCHES

EMBRACE
1994, CAST BRONZE AND ALUMINUM, 119 X 96 X 84 INCHES
COLLECTION OF THE ARTIST

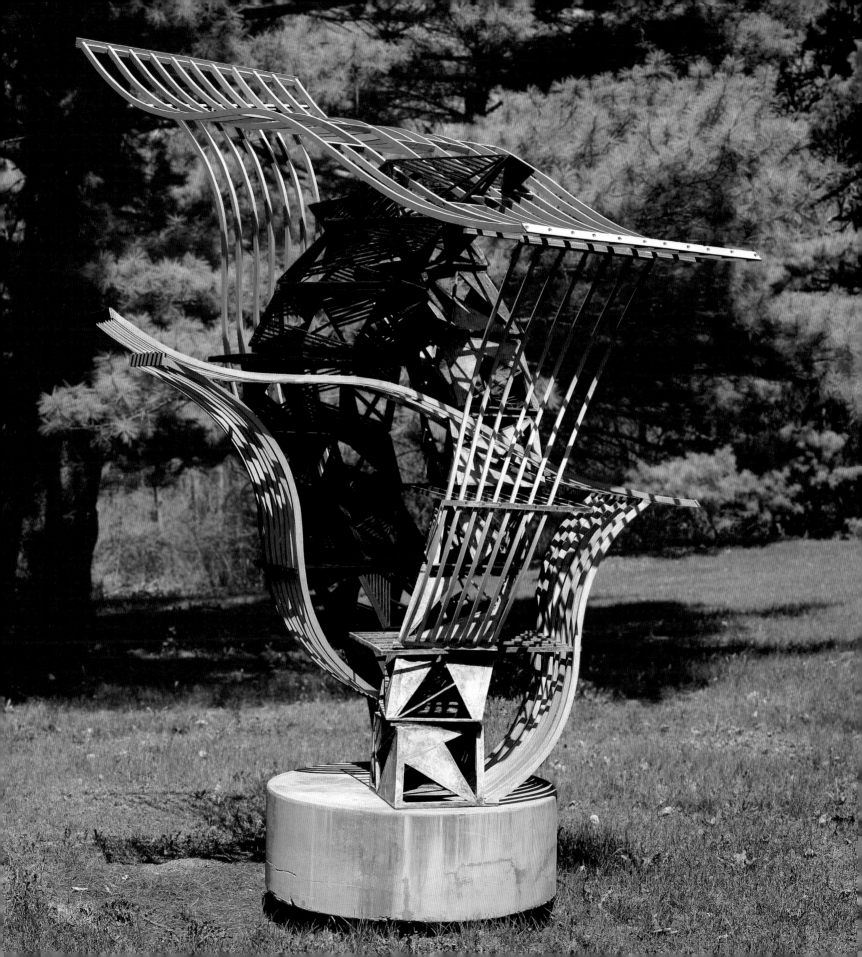

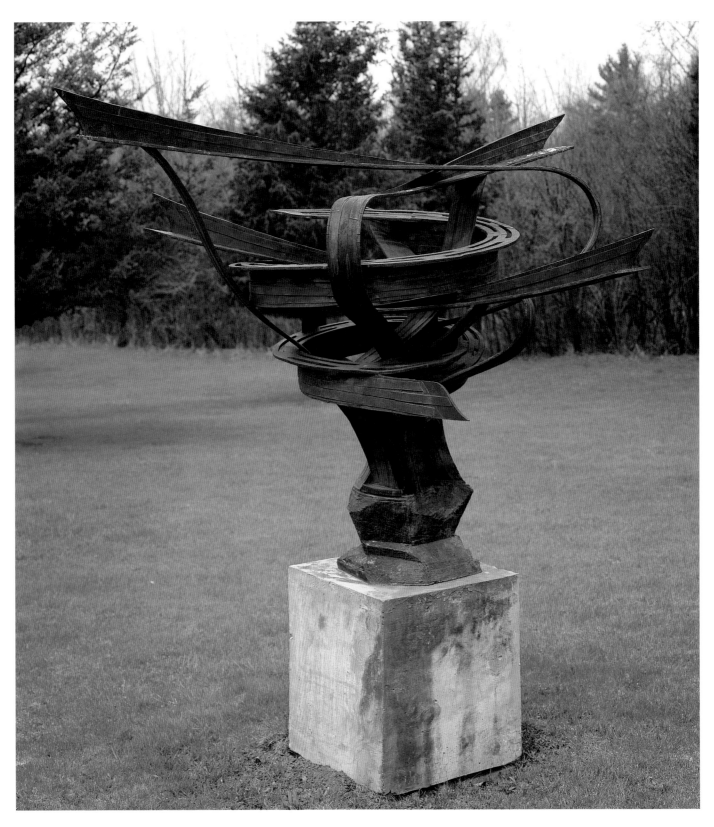

ESCAPE

1995, CAST BRONZE, 90 X 72 X 84 INCHES

COLLECTION OF SUSAN KALETSCH, SHARON, CONNECTICUT

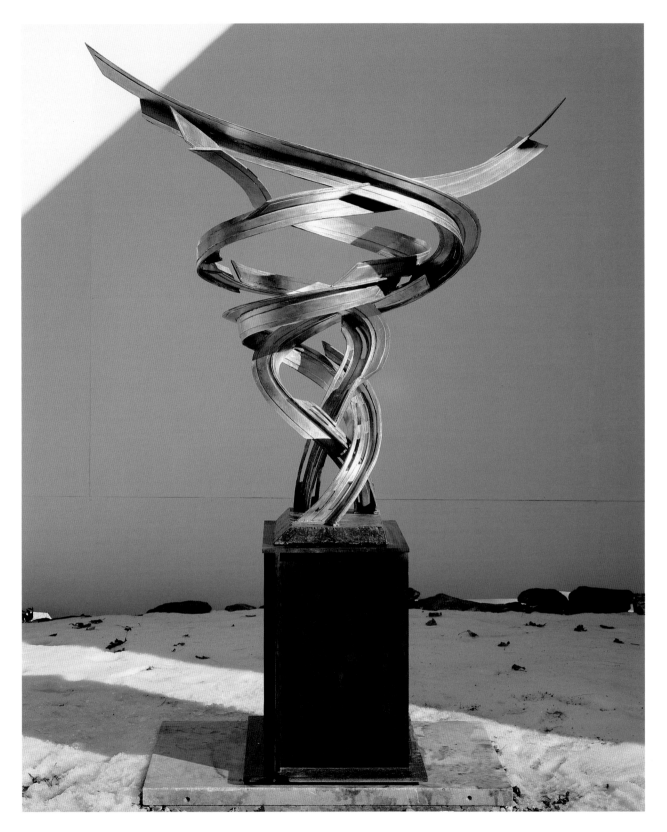

THE OPTIMIST
1998, CAST STAINLESS STEEL, 85 X 63 X 50 INCHES
COLLECTION OF THE OHIO VALLEY ART LEAGUE, HENDERSON, KENTUCKY

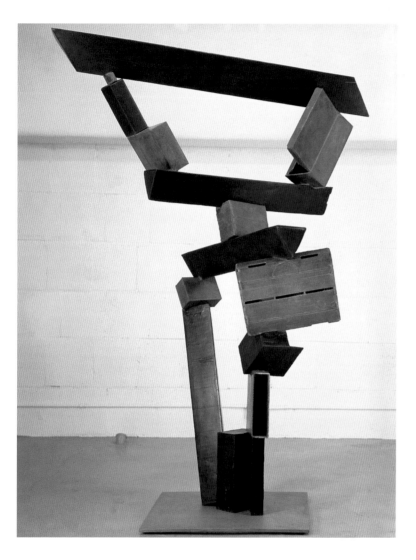

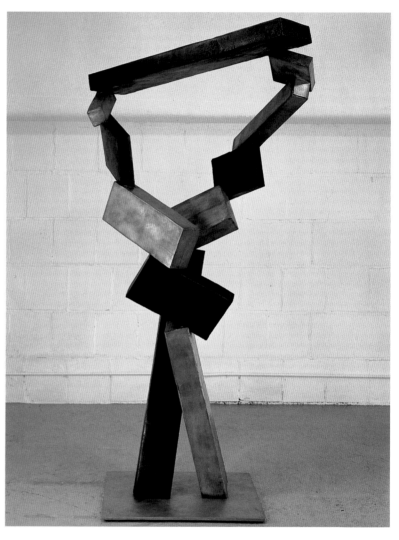

THE WORLD ON TIME
1997, CAST BRONZE, 99 X 60 X 36 INCHES
COLLECTION OF SANFORD AND RENEE BANK

DELIVERY
1998, CAST BRONZE, 91 X 47 X 45 INCHES
COLLECTION OF THE ARTIST

HANDLE WITH CARE
1997, CAST BRONZE, 93.5 X 62.5 X 34 INCHES
COLLECTION OF THE ARTIST

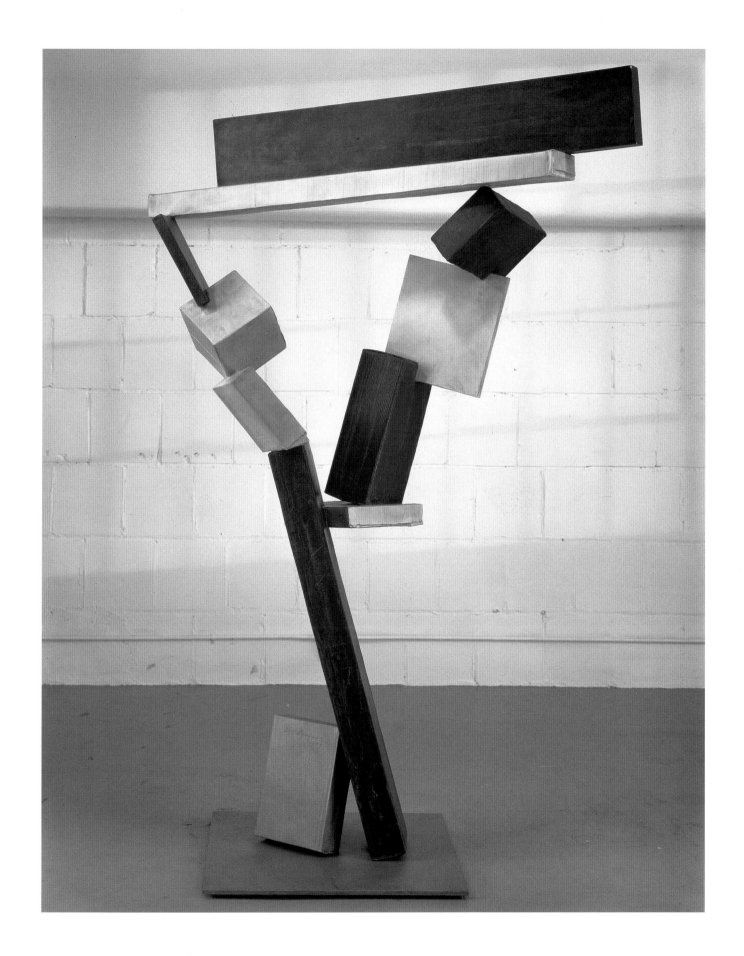

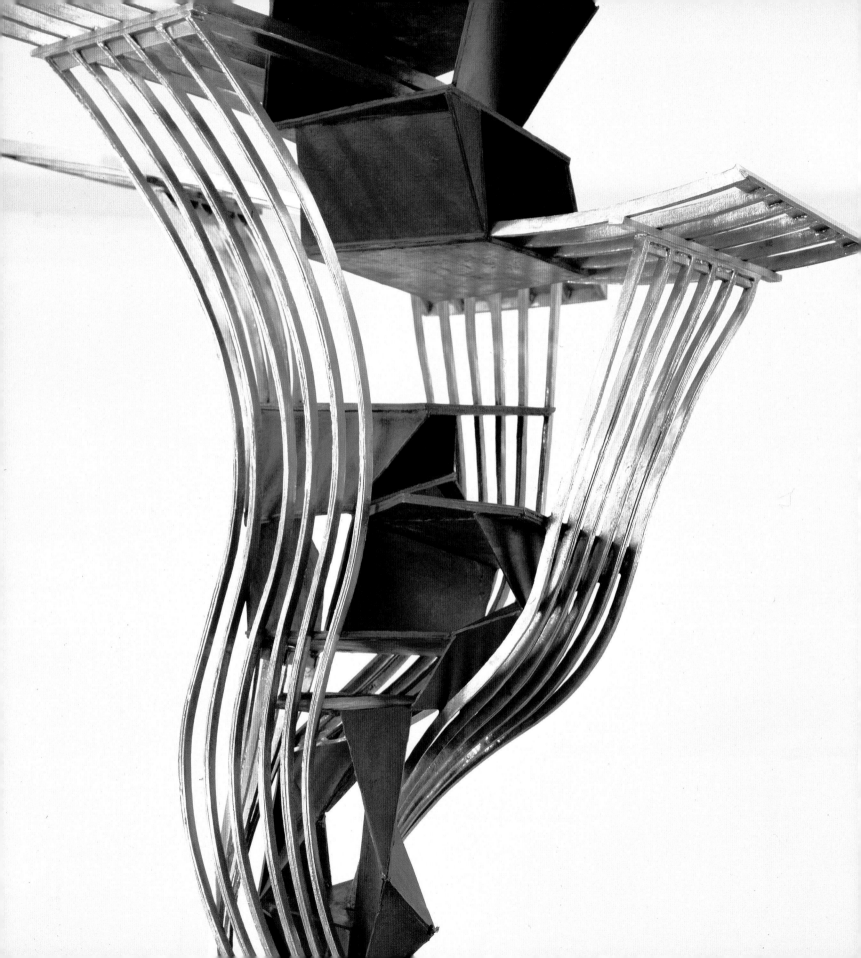

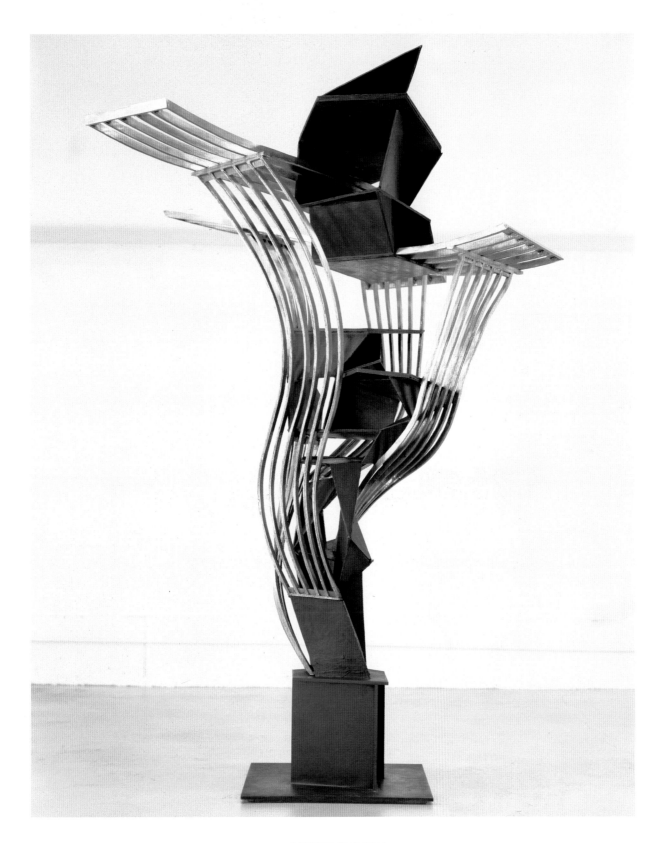

LEVITATION
1997, CAST BRONZE AND STAINLESS STEEL, 83 x 58 x 56 INCHES
PRIVATE COLLECTION, CORAL GABLES, FLORIDA

THE NEXT PHASE,
1997, CAST BRONZE AND CAST STAINLESS STEEL, 82 X 41 X 41 INCHES
COLLECTION OF MR. AND MRS. JAMES G. MARKS

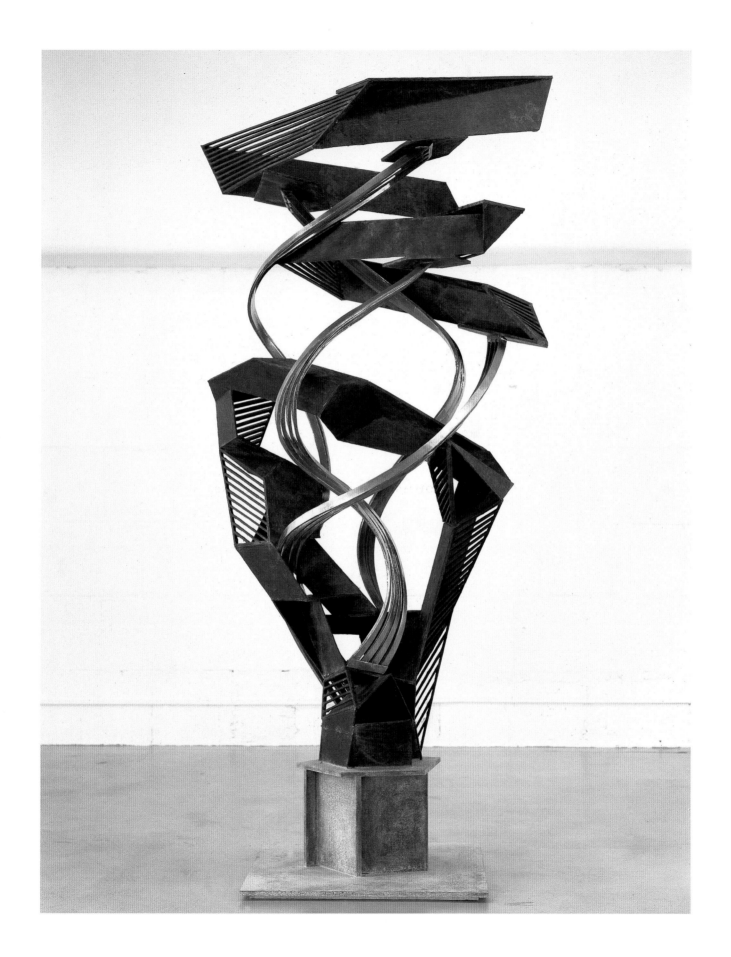

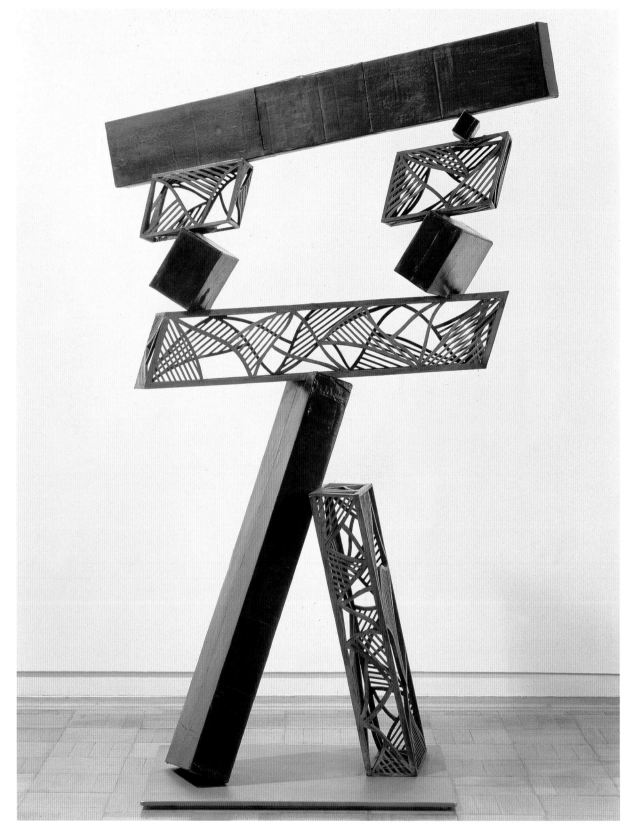

EASY WORK
1998, CAST BRONZE, 87 X 52 X 34 INCHES
COLLECTION OF TRACY ULLMAN AND ALLEN McKEOWN, LOS ANGELES, CALIFORNIA

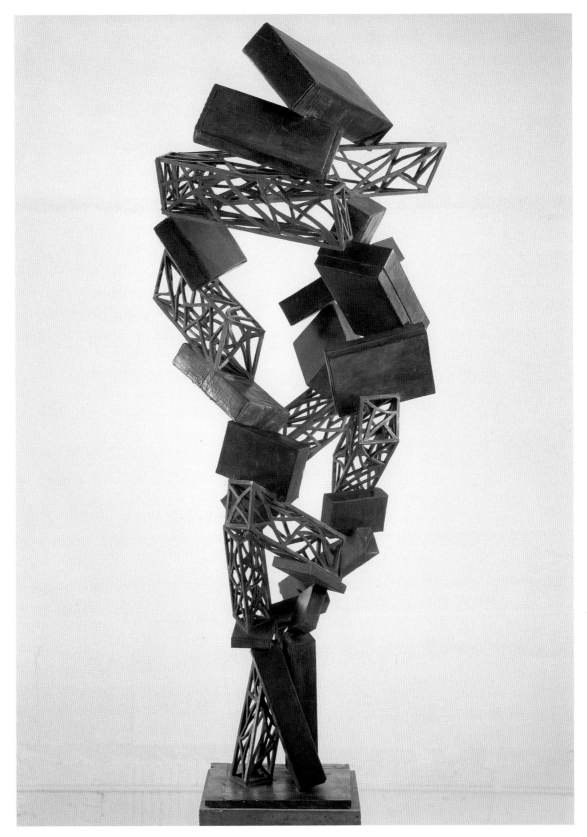

BRIDGE BUILDING
1999, CAST BRONZE, 85 x 22 x 22 INCHES
COLLECTION OF SCOTT F. LUTGERT, NAPLES, FLORIDA

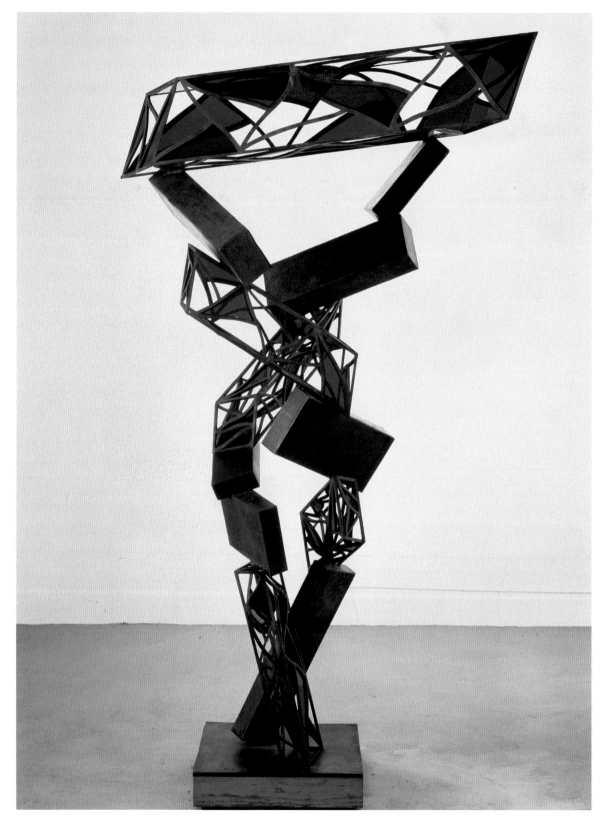

UNITING BLUE AND RED
1999, CAST BRONZE AND STAINED GLASS, 97 X 56 X 29 INCHES
COLLECTION OF THE ARTIST

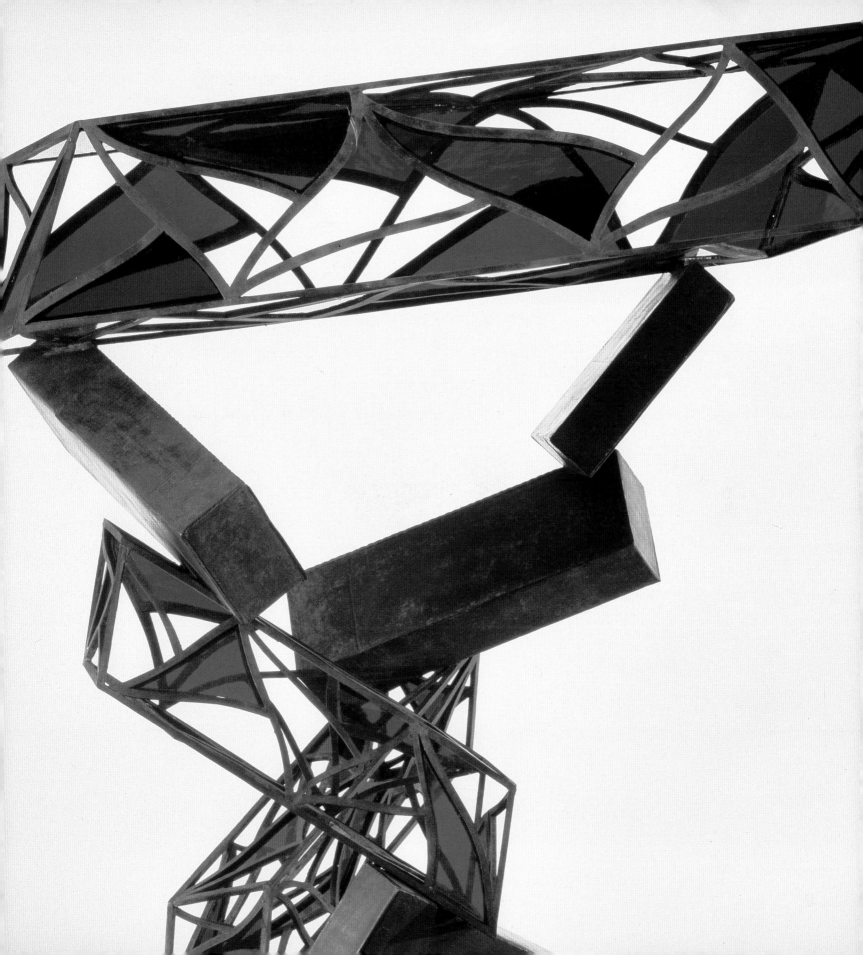

APOLLO
1998, CAST BRONZE, 97.5 X 39 X 32 INCHES
COLLECTION OF CREATIVE ARTISTS AGENCY, BEVERLY HILLS, CALIFORNIA

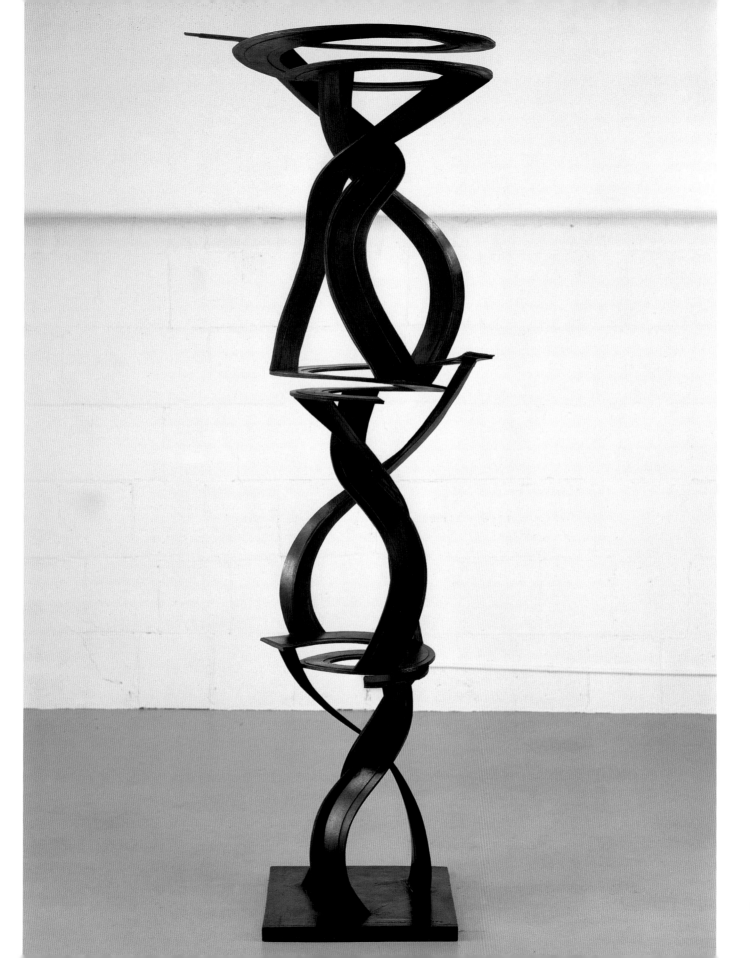

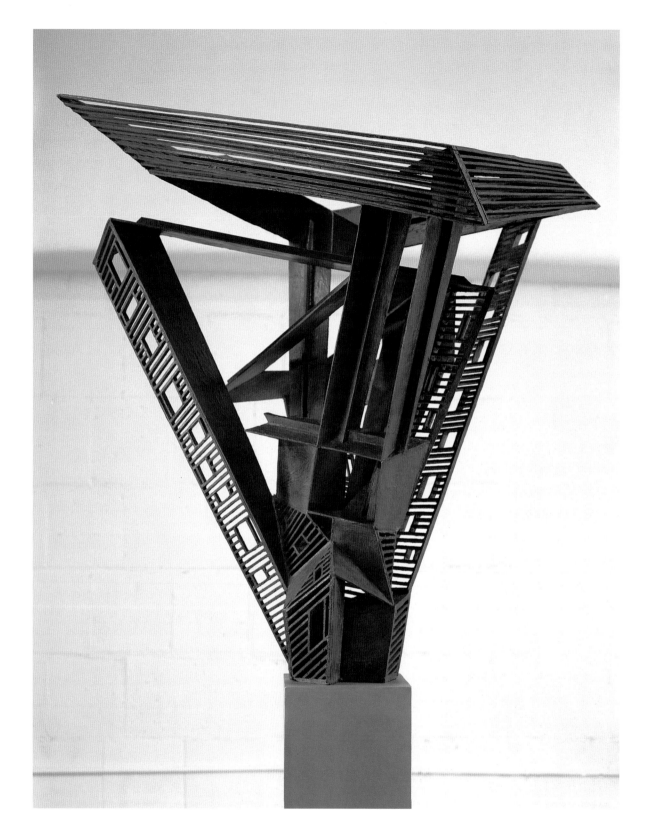

SHELTER

1998, CAST BRONZE, 78 X 45 X 44 INCHES

COLLECTION OF AIDAN AND ELIZABETH QUINN, NEW YORK

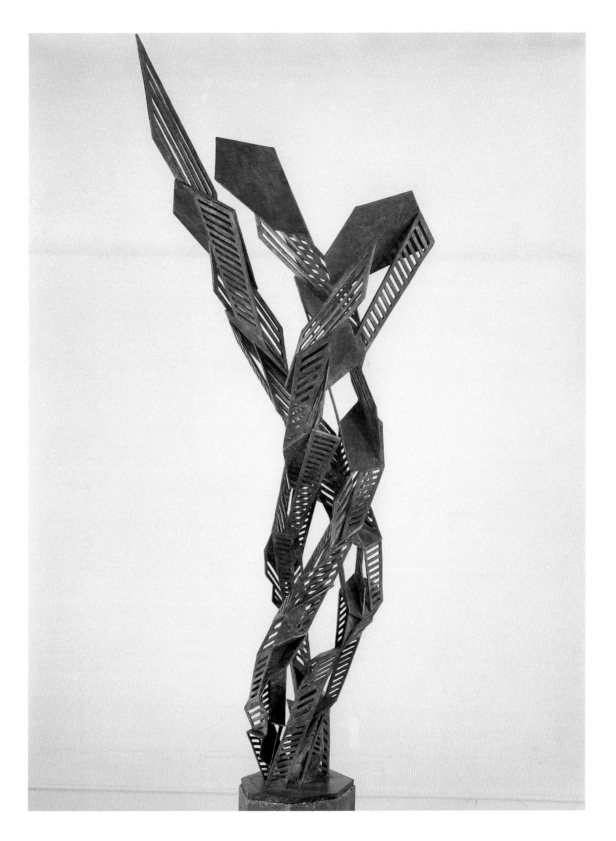

UNEVEN SIDES
2000, CAST BRONZE, 85 X 23 X 24 INCHES
COLLECTION OF SCOTT F. LUTGERT, NAPLES, FLORIDA

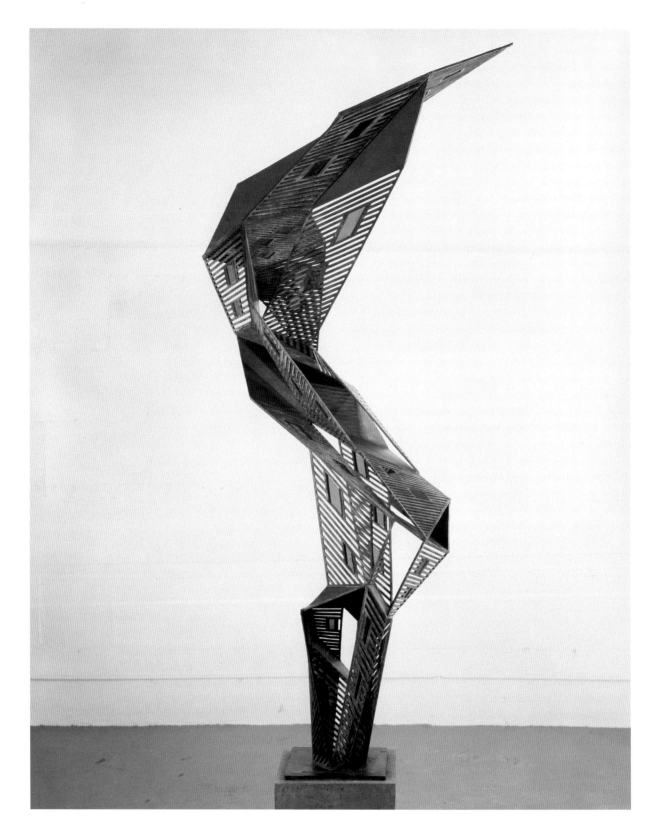

ROMAN HOLIDAY
1999, CAST BRONZE AND STAINED GLASS, 94 X 36 X 42 INCHES
PRIVATE COLLECTION, SOUTHERN FRANCE

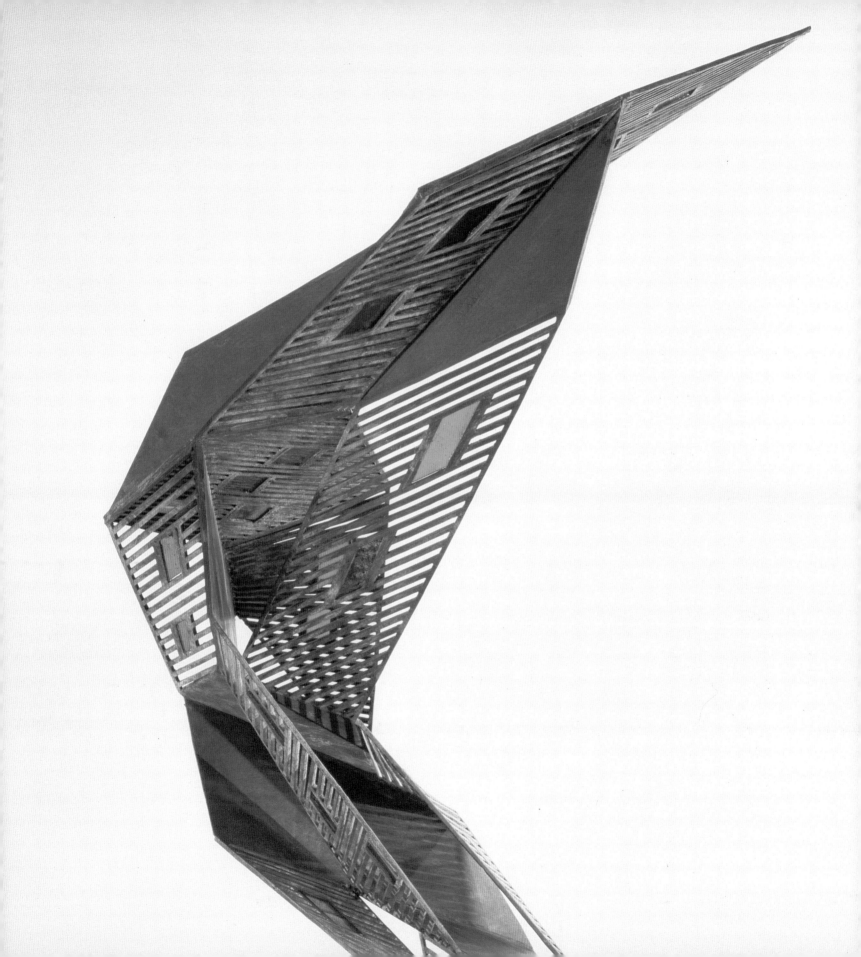

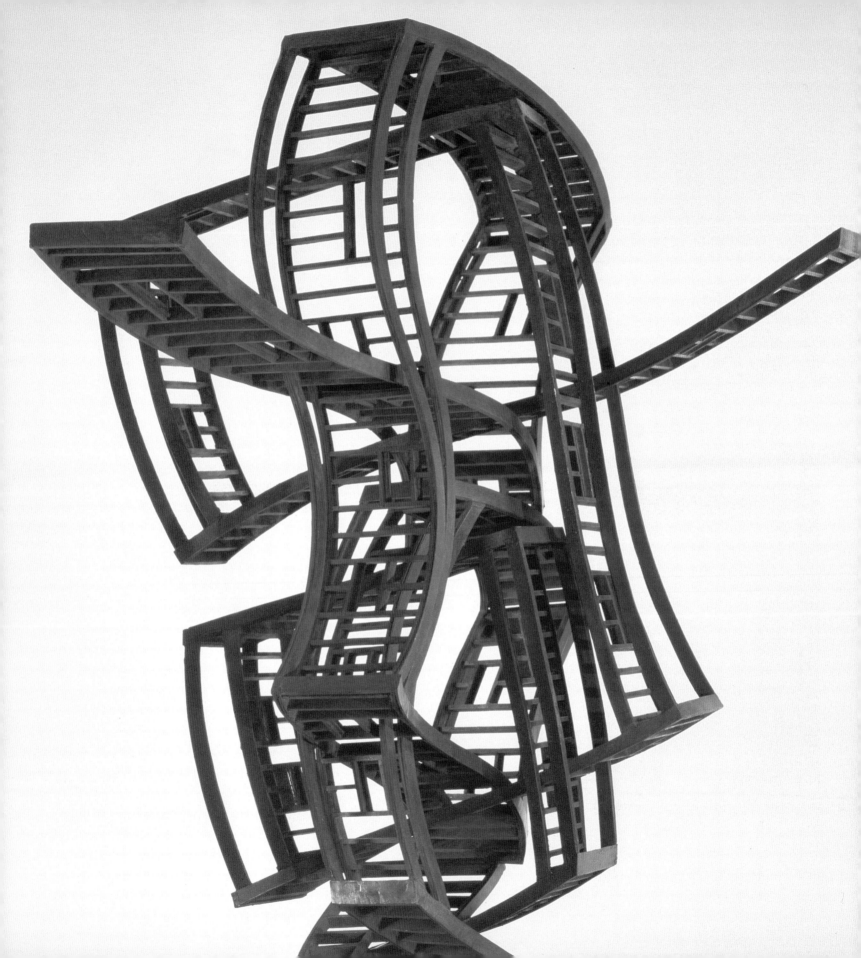

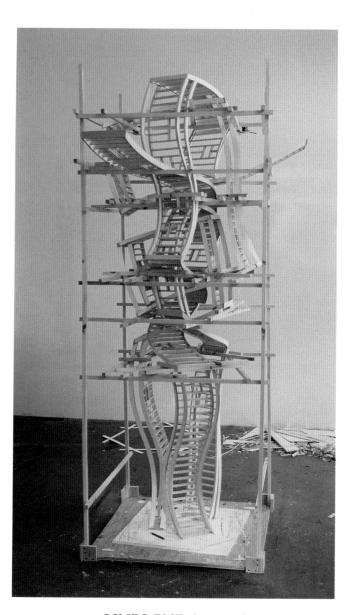

LINES END (MODEL)

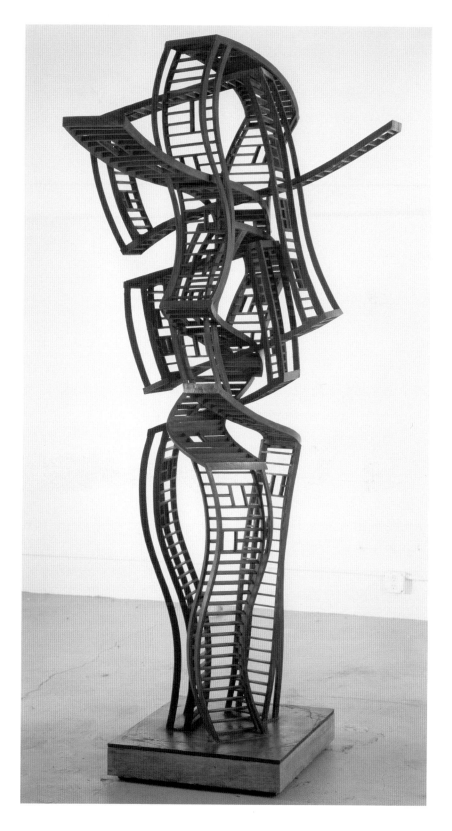

LINES END

1999, CAST BRONZE, 100 X 50 X 49 INCHES

COLLECTION OF SANFORD AND RENEE BANK

MERCURY
2000, STAINLESS STEEL, 83 X 44 X 26 INCHES
COLLECTION OF THE ARTIST

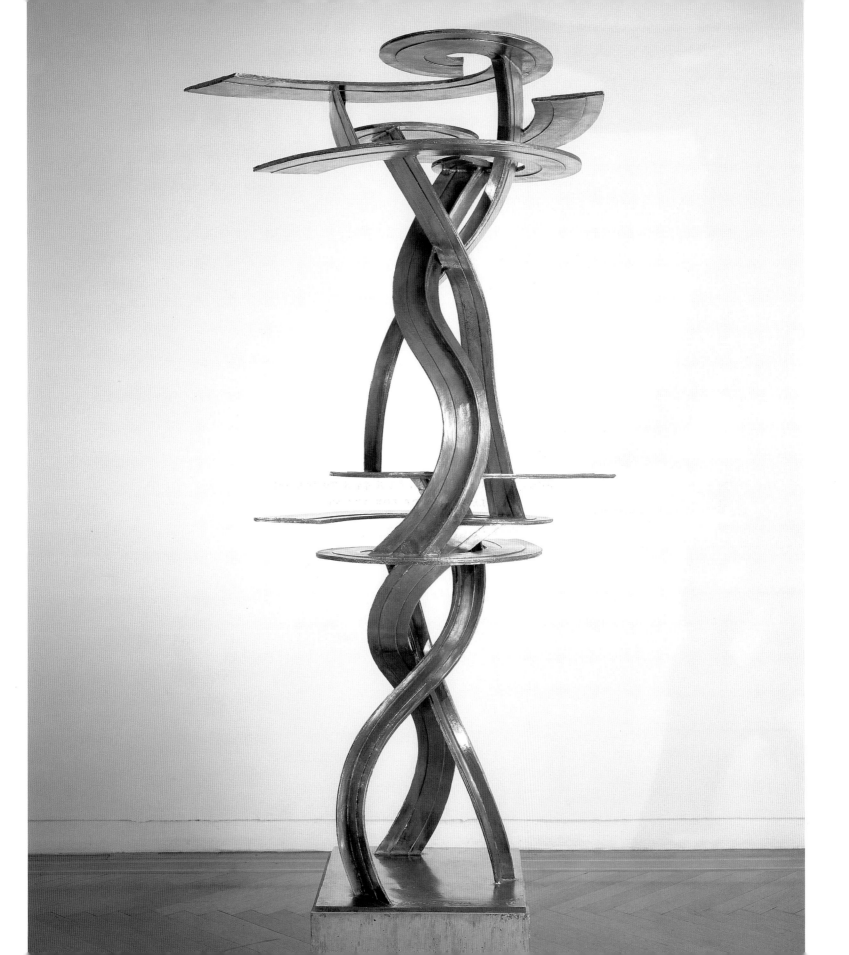

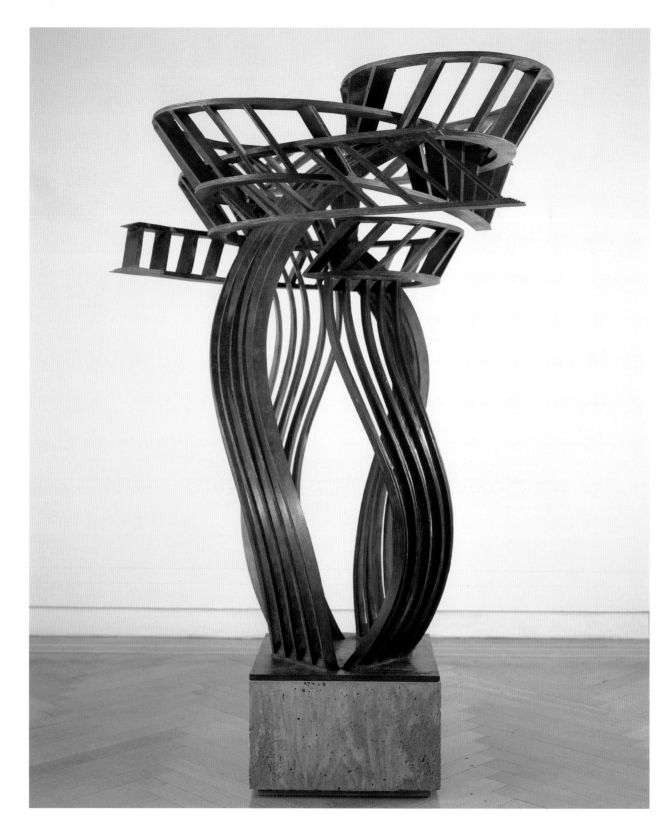

THE FOURTH REVOLUTION
2000, CAST BRONZE, 62 X 42 X 40 INCHES
COLLECTION OF THE ARTIST

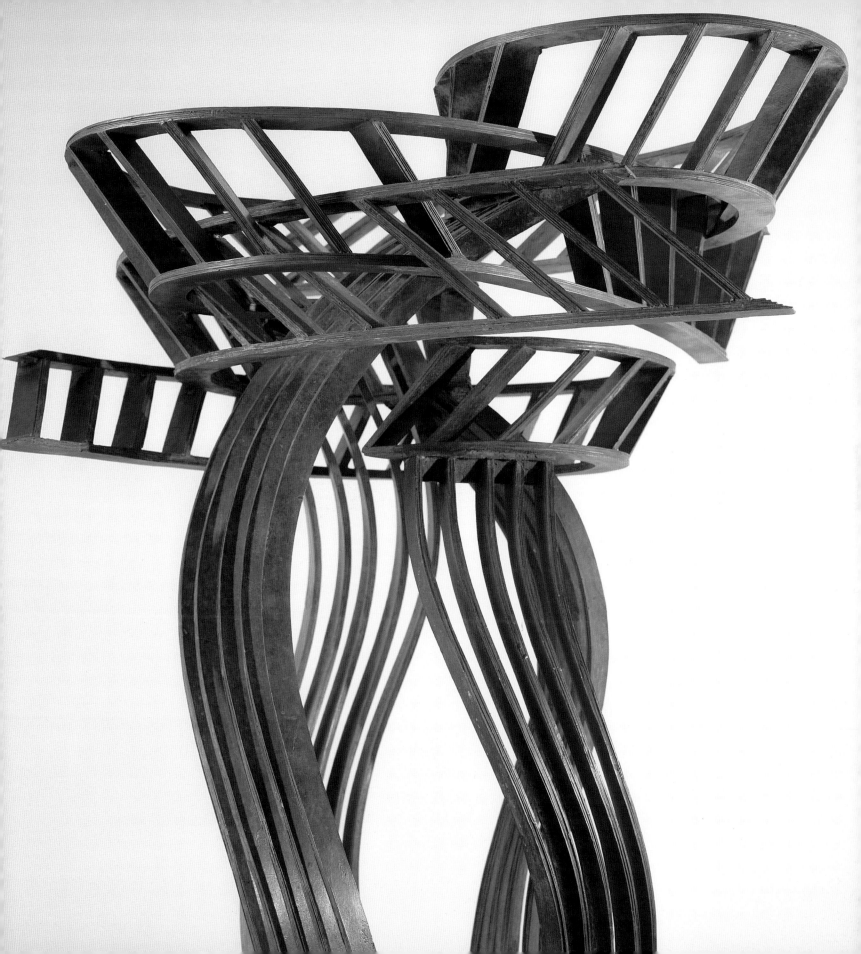

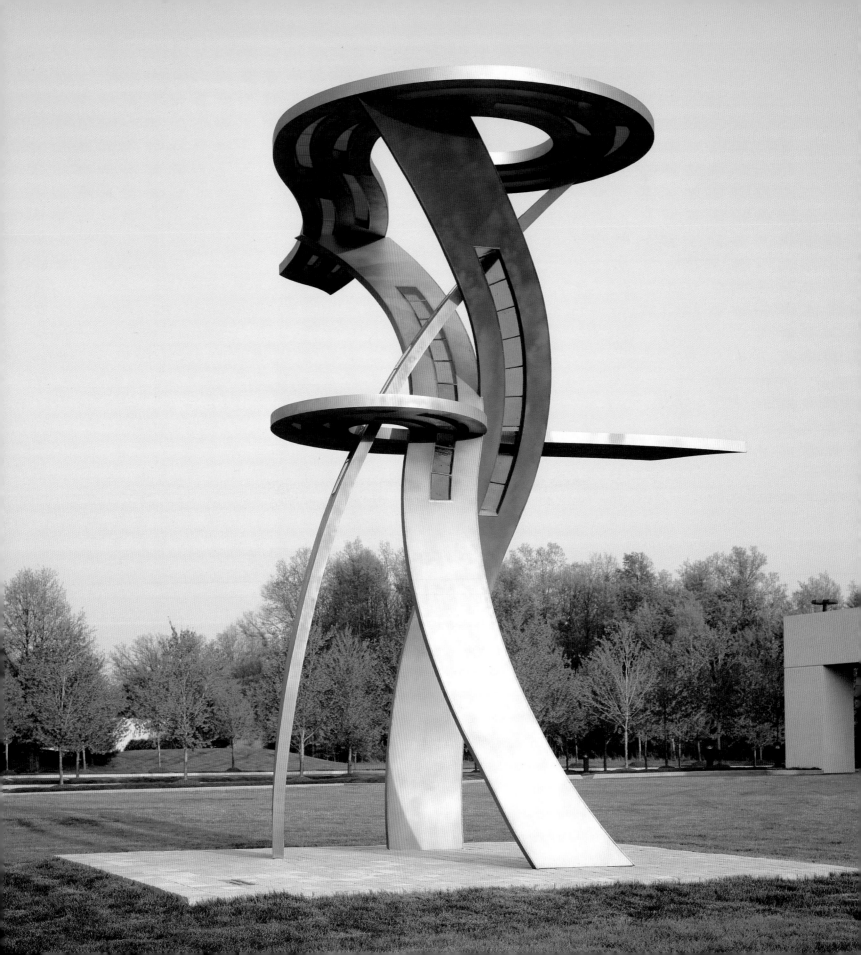

PRIMARY COMPASS
2000, STAINLESS STEEL AND STAINED GLASS, 20 X 23 X 18 FEET
PERMANENT INSTALLATION AT THE BUTLER INSTITUTE OF AMERICAN ART, YOUNGSTOWN, OHIO

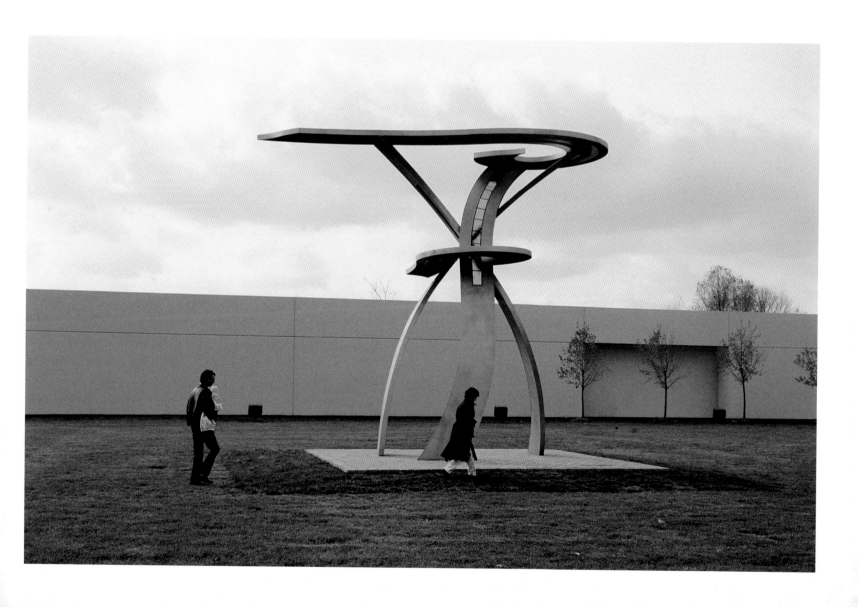

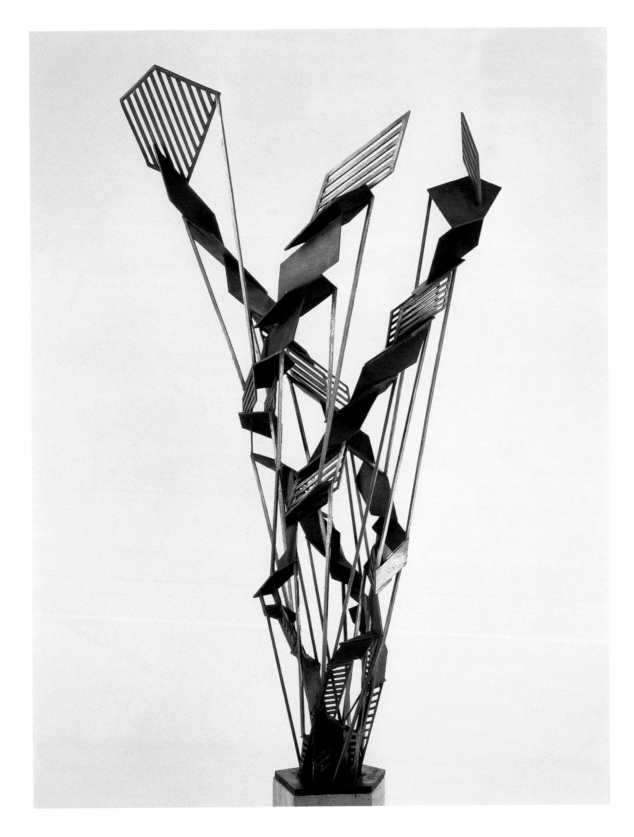

LOGICAL RULES
2000, CAST BRONZE, 84 X 24 X 23 INCHES
COLLECTION OF THE ARTIST

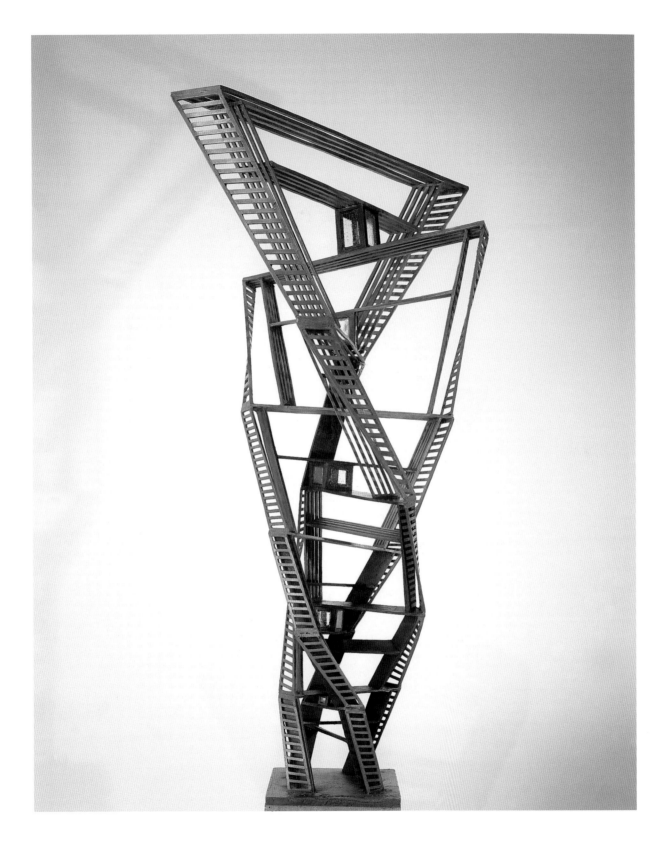

THE FIFTH FLOOR
2000, CAST BRONZE AND GLASS, 75 X 21 X 23 INCHES
COLLECTION OF KEVIN HUVANE, LOS ANGELES, CALIFORNIA

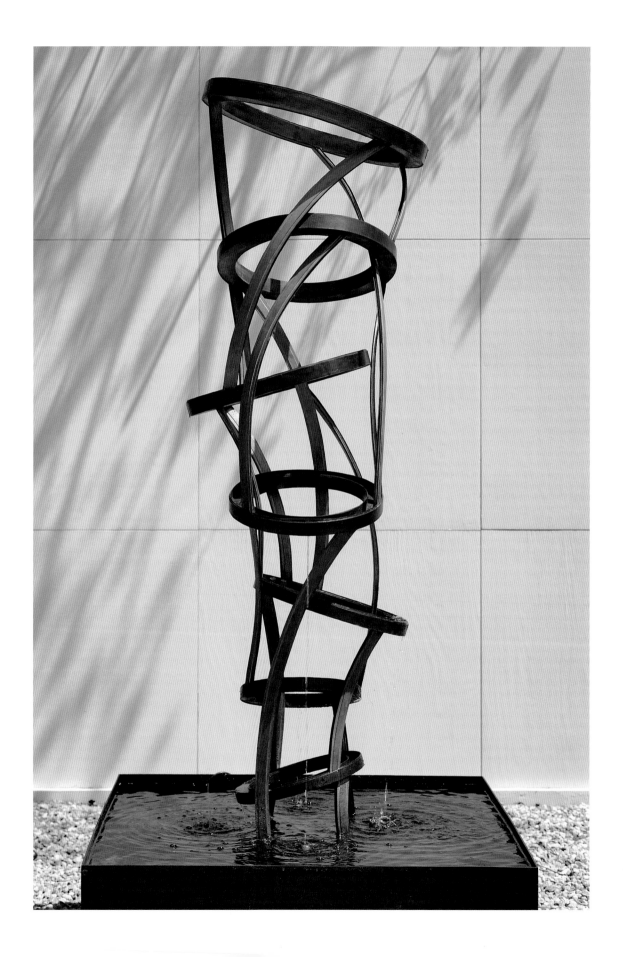

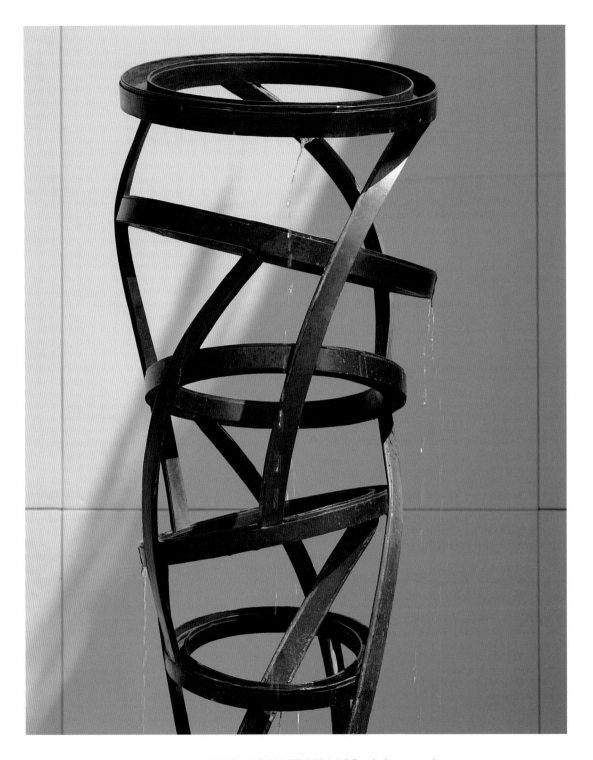

UNTITLED FOUNTAIN NO. 1 (DETAIL)
2000, CAST BRONZE AND WATER, 96 X 48 X 48 INCHES
COLLECTION OF THE ARTIST

UNTITLED FOUNTAIN NO. 2
2001, BRONZE AND WATER, 116 X 48 X 48 INCHES
COLLECTION OF THE ARTIST

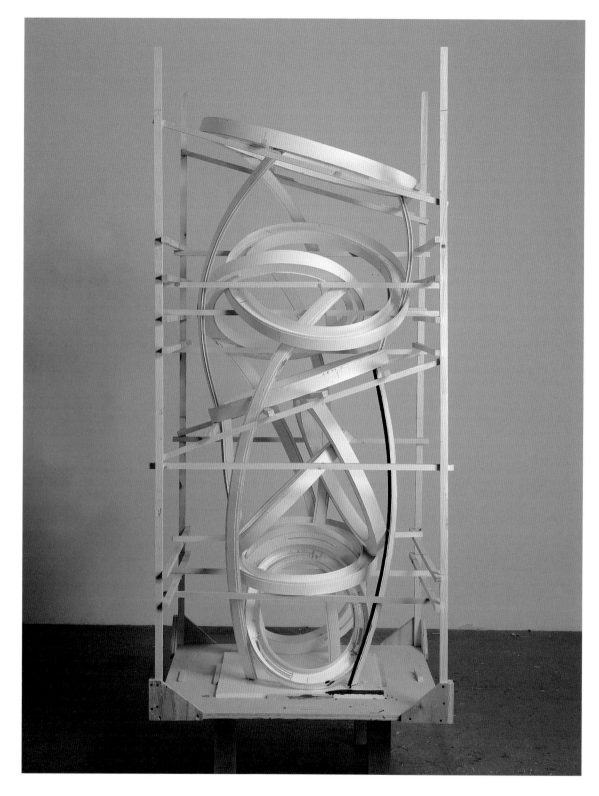

UNTITLED FOUNTAIN NO. 3
(BEFORE BRONZE CASTING)
2001, CARDBOARD, 77 X 32 X 26 INCHES
COLLECTION OF THE ARTIST

Don Gummer

1946 Born Louisville, Kentucky

1964–66 John Herron Art Institute, Indianapolis, Indiana

1966–70 School of the Museum of Fine Arts, Boston, Massachusetts

1973 BFA, MFA, Yale University School of Fine Arts, New Haven, Connecticut

One-Man Exhibitions

1973 112 Greene Street, New York

1974 Artist's Space, New York

1977 Sperone Westwater Fischer, New York

1979 Castle Clinton, Battery Park, New York

Sperone Westwater Fischer, New York

1980 Dag Hammarskjold Plaza, New York

The Akron Art Museum, Akron, Ohio

1982 Sperone Westwater Fischer, New York

Seagram Plaza, New York

1984 Sperone Westwater, New York

1986 Sperone Westwater, New York

1987 Evansville Museum of Arts and Science, Evansville, Indiana: sculpture, permanent installation

1988 Sperone Westwater, New York

1990 Sperone Westwater, New York

1992 Daniel Weinberg Gallery, Santa Monica, California

1993 Kitakyushu International Center, Kitakyushu, Japan: two sculptures, permanent installation

1994 Fred Hoffman Gallery, Los Angeles, California

1996 Sperone Westwater, New York

1998 NationsBank Plaza, Charlotte, North Carolina

1999 Salander-O'Reilly Galleries, New York

2000 Eckert Fine Arts, Naples, Florida

Salander-O'Reilly Galleries, New York

2001 Butler Institute of American Art

Awards

1966–70 Ford Foundation Fellowship, Boston Museum School

1970 Clarissa Bartlett Traveling Fellowship

1973 The Pardee Prize for sculpture, Yale University

1975 National Endowment for the Arts

1976 CAPS grant

1978 Louis Comfort Tiffany Foundation Grant

1978 National Endowment for the Arts

Group Exhibitions

1978 Sperone Westwater Fischer, New York

1979 Sperone Westwater Fischer, New York

Eight Sculptors, Albright Knox Gallery, Buffalo, New York

1980 *Current/New York*, Joe and Emily Lowe Art Gallery, University of Syracuse, Syracuse, New York

Art in Our Time, H.H.K. Foundation for Contemporary Art, Milwaukee, Wisconsin

1981 *James Biederman, Don Gummer, Nigel Hall, Mel Kendrick, Avital Oz*, The Clocktower, New York

Media Relief, John Weber Gallery, New York

Instruction Drawings, The Gilbert and Lila Silverman Collection, Cranbrook Academy of Art Museum, Bloomfield Hills, Michigan

New Visions, The Aldrich Museum of Contemporary Art, Ridgefield, Connecticut

Summer Exhibition, Sperone Westwater Fischer, New York

35 Artists Return to Artist's Space, Artist's Space, New York

1982 *Biederman/Gummer/Kendrick*, The Arts Club of Chicago, Chicago, Illinois

1982 Invitational Exhibition, The Berkshire Museum, Pittsfield, Massachusetts

1983 *Concepts in Construction: 1910–1980*, Traveling exhibition organized and circulated by Independent Curators Incorporated, New York. Travels 1983–1985

1984 *A Decade of New Art*, Artist's Space, New York

1985 *A Sculpture on the Wall*, Aldrich Museum of Contemporary Art, Ridgefield, Connecticut

1987 *The Kentuckians: 1987*, National Arts Club, New York; Owensboro Museum of Fine Art, Owensboro, Kentucky

1988 *40th Annual Academy/Institute Purchase Exhibition*, American Academy and Institute of Arts and Letters, New York

1990 *Summer Sculpture Exhibition*, Sperone Westwater, New York

Artists for Amnesty, Blum Helman, Germans van Eck, New York

Recent Works, Embassy Suites Hotel, New York

1993 *Yale Collects Yale*, Yale University Art Gallery, New Haven

1998 Salander-O'Reilly Galleries, New York

Defining Structures, NationsBank Plaza, Charlotte, North Carolina

Public Collections

Chase Manhattan Bank, New York

Chemical Bank, New York

Creative Artists Association, Los Angeles

The Equitable, New York

Evansville Museum of Arts, History & Science, Evansville, Indiana

Hiroshima Lying-in Hospital, Hiroshima, Japan

International Creative Management, New York

Joseph E. Seagram Company, New York

Kitakyushu International Center, Kitakyushu, Japan

Louisiana Museum, Humlebaek, Denmark

McCrory Corporation, New York

Public Commissions

Ohio Valley Art League, Henderson, Kentucky

Site specific outdoor permanent sculpture. Butler Institute of American Art, Youngstown, Ohio

Evansville Museum of Arts, History & Science, Evansville, Indiana

Kitakyushu International Center, Kitakyushu, Japan

Hibicki Concert Hall, Kitakyushu, Japan

Bibliography

Baker, Kenneth. "Sperone Westwater, New York; Exhibit." *Art in America* 72 (October 1984): 203–204.

Balken, Debra Bricker. Introduction to *1982 Invitational Exhibition.* Pittsfield, Massachusetts: The Berkshire Museum, 1982.

Carr, Carolyn Kinder. "An Interview with Don Gummer." *Dialogue,* November/December 1980, pp. 44–47.

Cathcart, Linda A. *A Decade of New Art.* New York, 1985.

Cecil, Sarah. "Don Gummer." *ArtNews* 81 (September 1982): 172.

Danoff, I. Michael. Introduction to *Art in Our Time.* Milwaukee, Wisconsin: H.H.K. Foundation for Contemporary Art, 1980.

Feinberg, Jean E., ed. *Interpretations '79.* New York: National Park Service and the Lower Manhattan Cultural Council, 1979.

Frank, Peter. *Los Angeles Weekly,* 1 April 1994.

Glueck, Grace. "A Critic's Guide to the Outdoor Sculpture Show." *New York Times,* 11 June 1982, p. 75.

———. "Don Gummer." *New York Times,* 26 October 1979.

Haydon, Harold. *Chicago Sun-Times,* 12 February 1982.

Heinemann, Sue. *Artforum* 12 (March 1974): 80–81.

Hogrefe, Jeffrey. "New York, New York: Arts." *Washington Post,* 10 April 1984, p. C7.

Huntington, Richard. "Albright Sculpture Exhibit a Treat." *Buffalo Courier Express,* 1 April 1979.

Kandel, Susan. *Los Angeles Times,* 15 April 1994.

Kotz, Mary Lynn. "Don Gummer: Building a House without Plans." *Sculpture,* 18 April 1999.

Krantz, Claire Wolf. "James Biederman/Don Gummer/Mel Kendrick." *New Art Examiner,* 1982, p. 14.

Lawson, Kay. "Castle Clinton." *Village Voice,* 2 July 1979, p. 63.

———. "Imperialism with a Grain of Salt." *Village Voice,* 17 September 1979, p. 79.

———. *New York Magazine* 15 (7 June 1982): 75.

Mayer, Rosemary. *Arts Magazine* 4 (September/October 1973): 67.

Newhall, Edith. "Fast Track." *New York Magazine,* 16 May 1988.

"New Sculpture at Fort Clinton Blends with the Shape of Its Surroundings." *New York Times,* 29 August 1979, p. 20.

Owensboro Museum of Fine Art. *The Kentuckians.* Owensboro, Kentucky: Owensboro Museum of Fine Art, 1987, pp. 20–21.

Phillips, Deborah C. *ArtNews* 80 (September 1981): 234–236.

Raynor, Vivien. *New York Times,* 20 April 1984, p. C23.

———. *New York Times,* 10 February 1985.

Russell, John. *New York Times,* 4 March 1977, p. C21.

———. *New York Times,* 20 May 1988, p. C23.

Sandler, Irving. *Concepts in Construction: 1910–1980.* New York: Independent Curators Incorporated, 1983.

Schultz, Douglas. *Eight Sculptors.* Buffalo, New York: Albright Knox Gallery, 1979, pp. 5, 6, 26–32.

Schwendeewien. "Don Gummer." *Sculpture,* (November/December 1988): 32.

"Sculpture: New Directions." *Buffalo Courier Express,* 11 March 1979.

Sheffield, Margaret. *Artforum* 18 (January 1980): 72–73.

Siegel, Lee. "Sperone Westwater Gallery, New York; Review." *ArtNews* 95 (November 1996): 134.

Stimson, Paul. "Don Gummer at Sperone Westwater Fischer and Seagram Plaza." *Art in America* 71 (January 1983): 121–122.

Tannenbaum, Judith. "Don Gummer." *Arts Magazine* 54 (January 1980): 27, 45.

Tannenbaum, Phyllis. *Art in America* 68 (February 1980): 130.

The Gilbert and Lila Silverman Collection. *Instruction Drawings.* Bloomfield Hills, Michigan: Cranbrook Academy of Art Museum, 1981, pp. 22, 67.

Tuchman, Phyllis. *Biederman/Gummer/Kendrick.* Chicago, Illinois: Arts Club of Chicago, 1982.

Yau, John. "Don Gummer." *Artforum* 23 (September 1984): 116–117.

Zimmer, William. "Mask Marvel." *Soho Weekly News,* 8 November 1979, p. 58.

Photo credits

John Emmons 26
Motoaki Etoh 22
Mitsuhiro Kikko 24
Douglas Parker 27, 29, 30, 31, 32
Whitelight Photo 20
Tom Rosenthal 12, 14, 19, 21, 23, 25, 33
Joe Rudenic 56
Paul Waldman 34, 35, 37, 39, 40, 41, 42, 45, 46, 47, 48, 51, 53, 54, 58, 60, 61, 62